The Color Garden:
Using color to grow your creativity

Rubina Syed

Copyright © Rubina Syed

All rights reserved

ISBN-10: 1540646831
ISBN-13: 978-1540646835

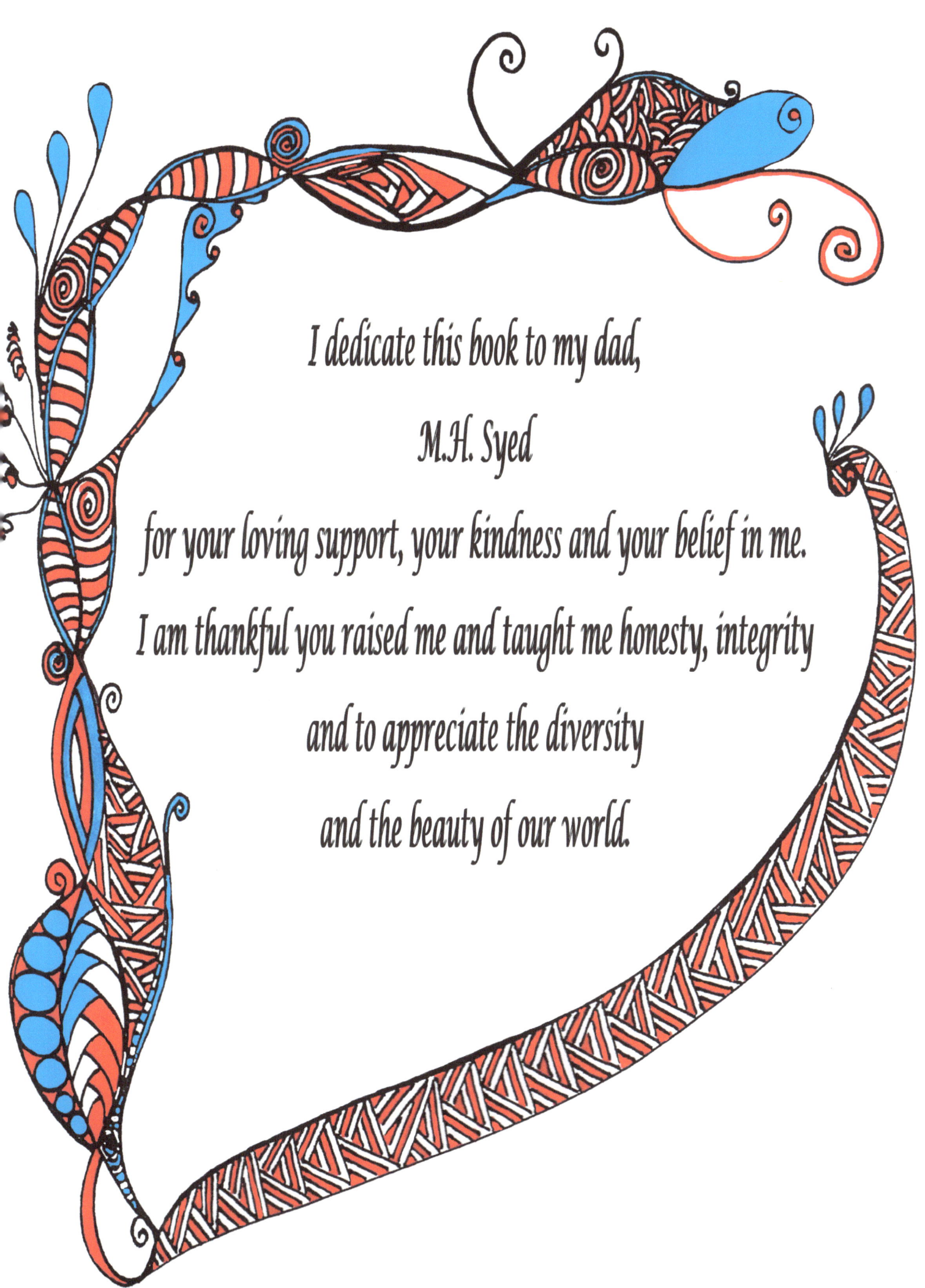

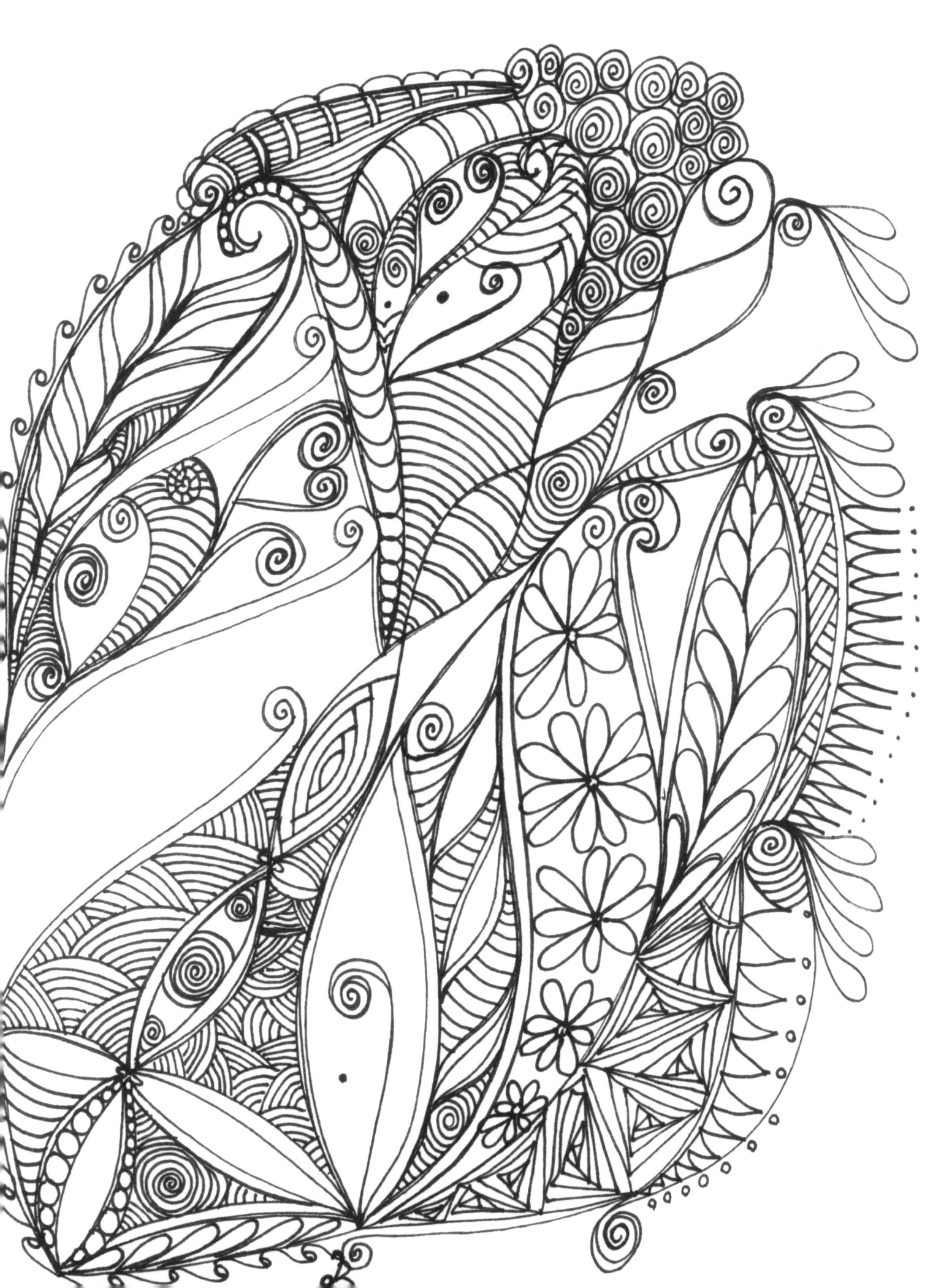

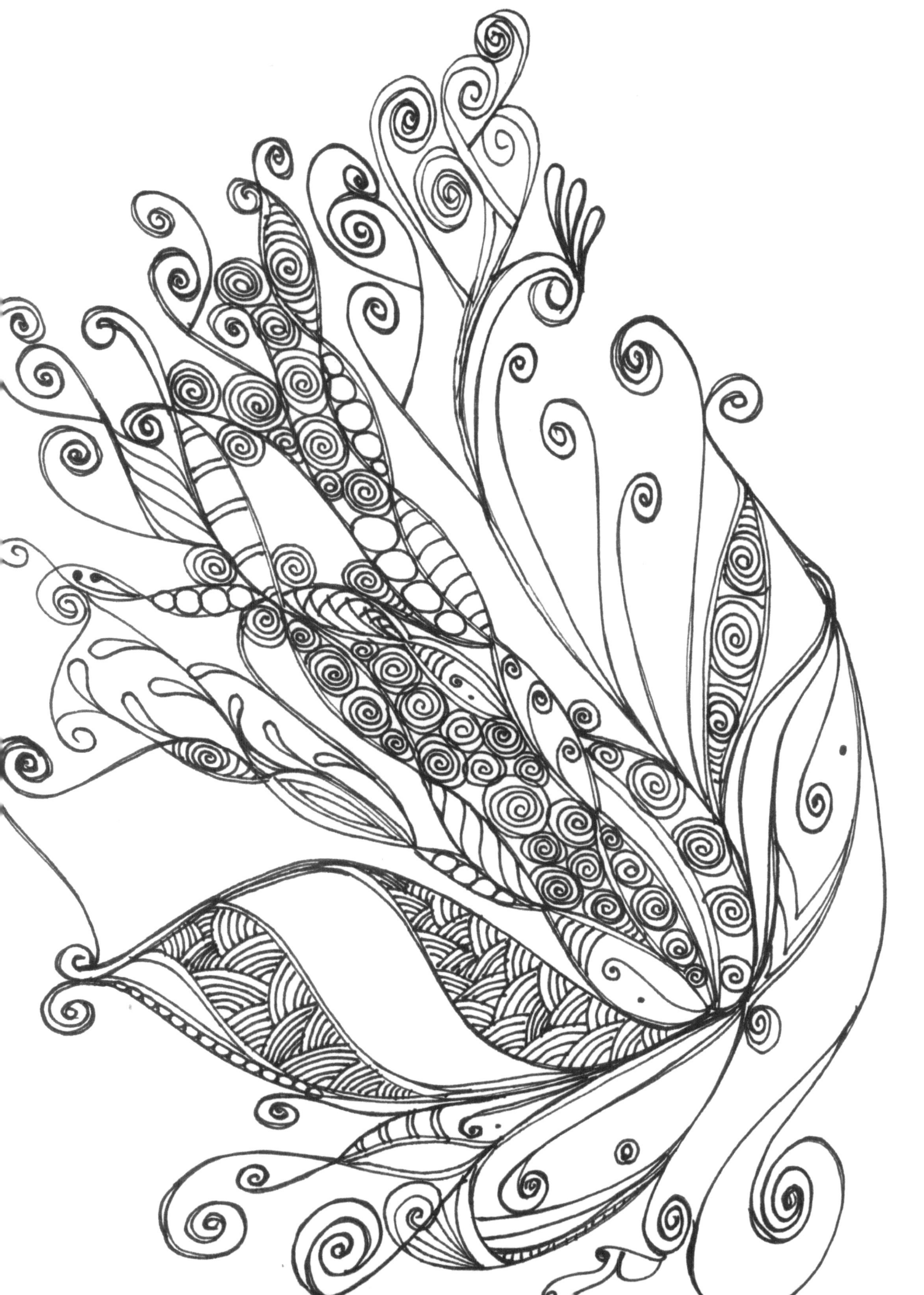

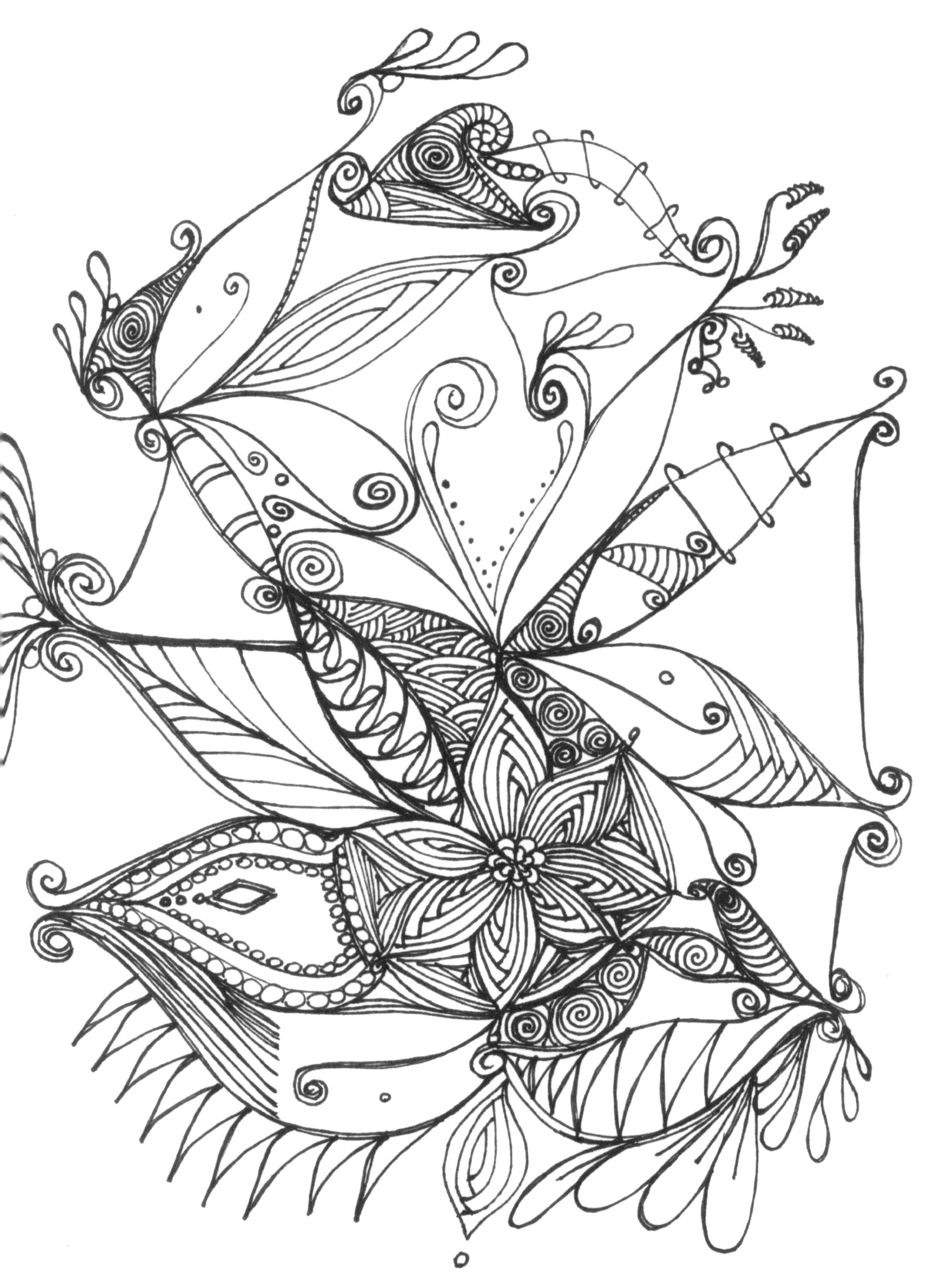

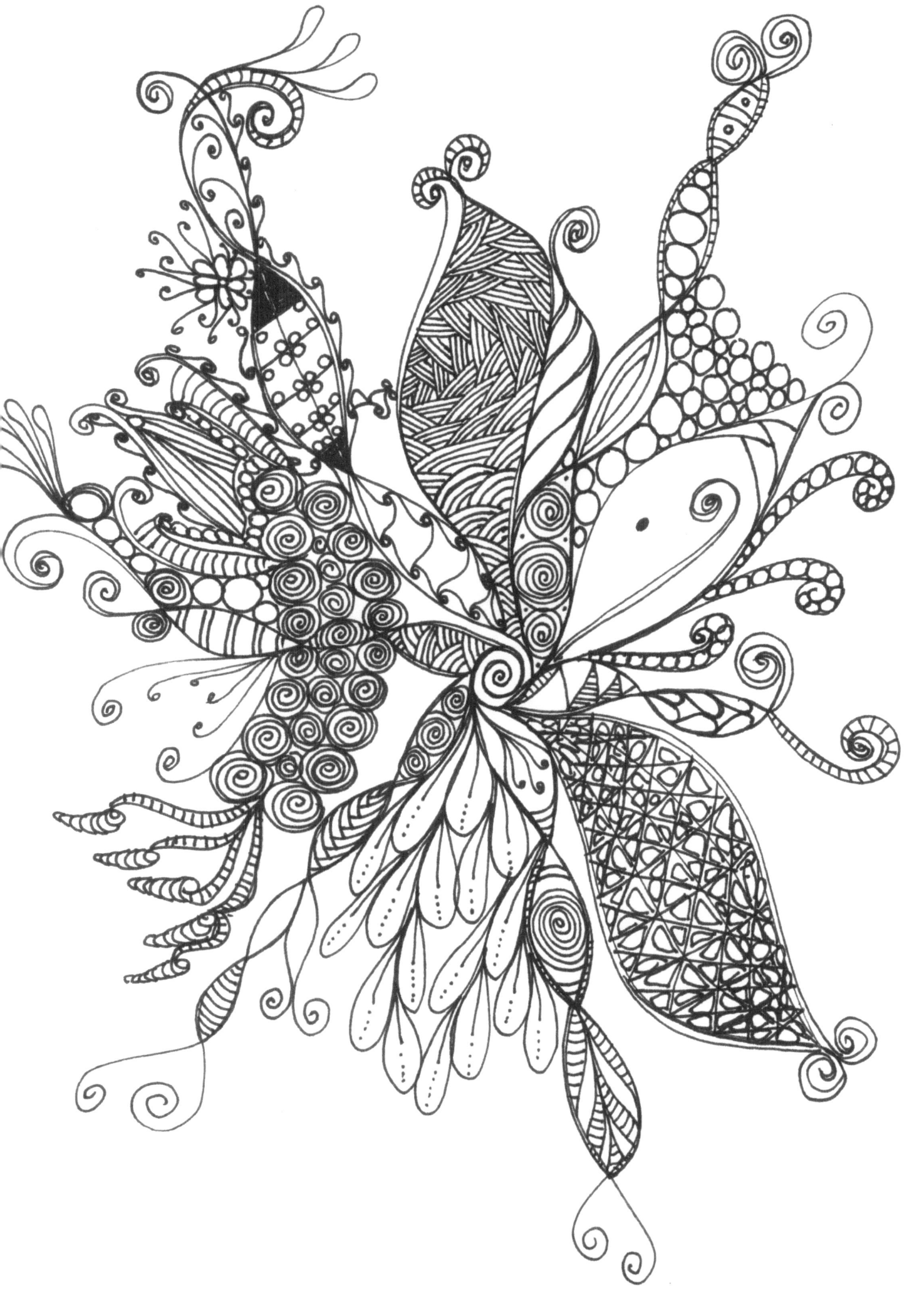

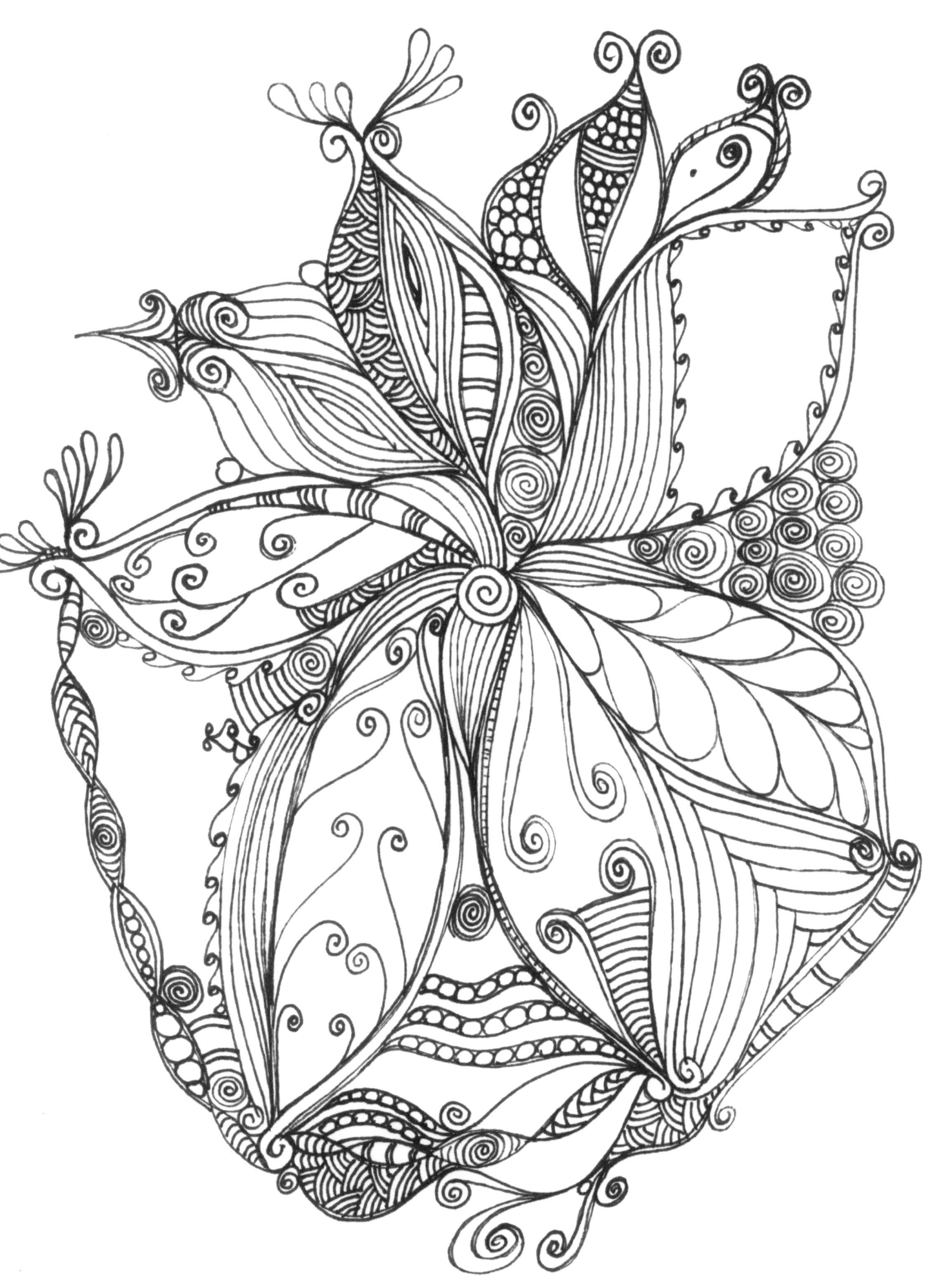

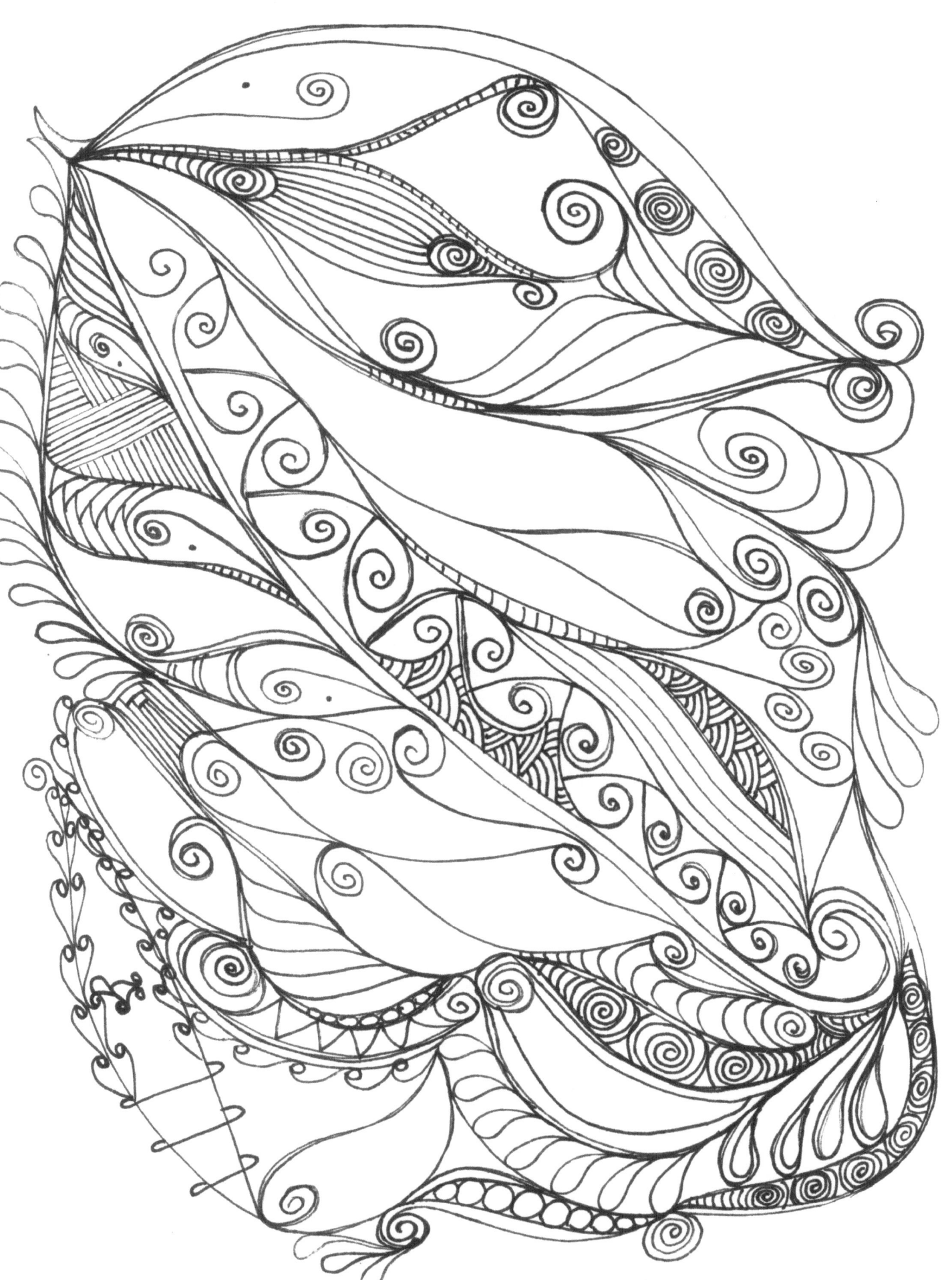

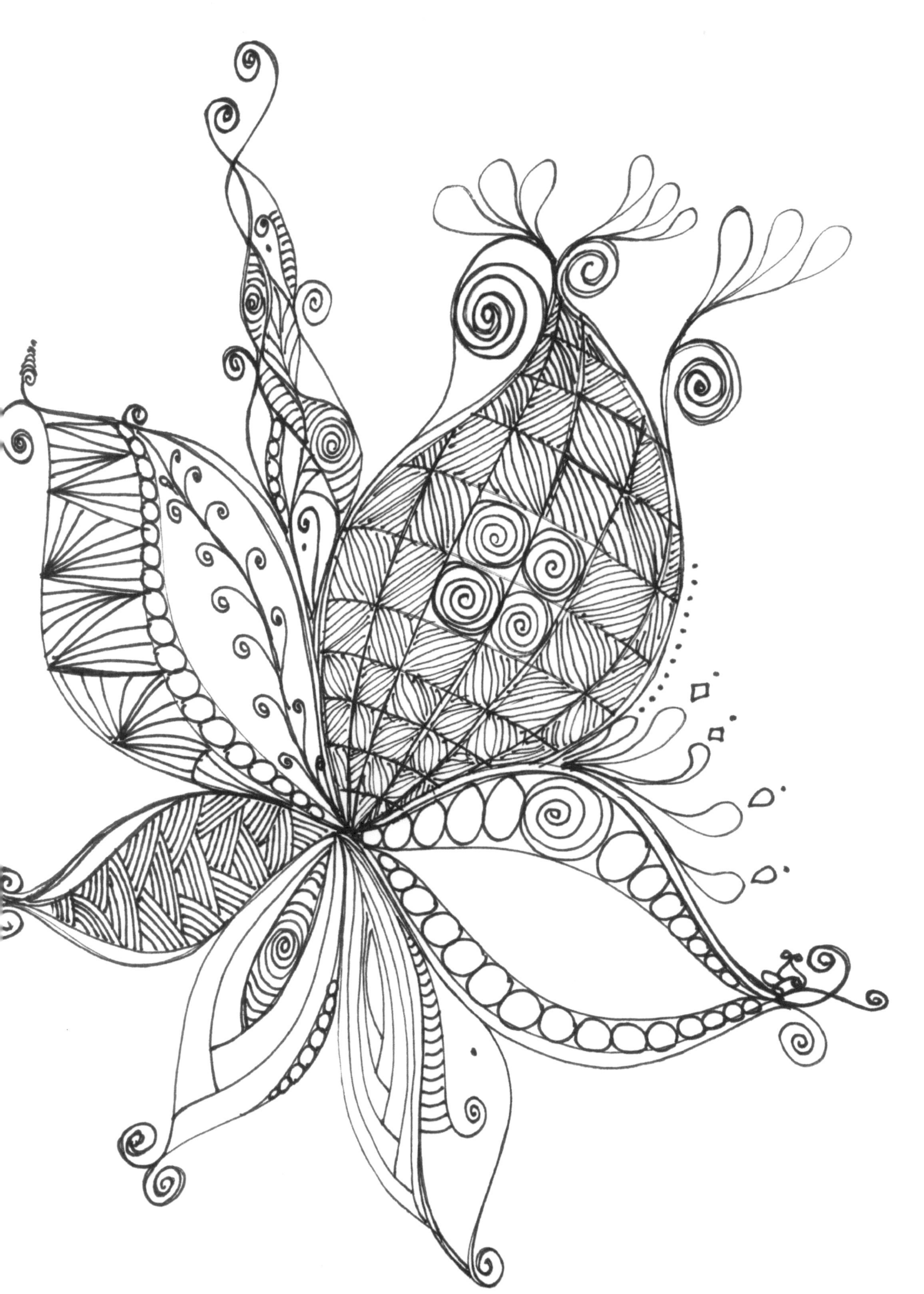

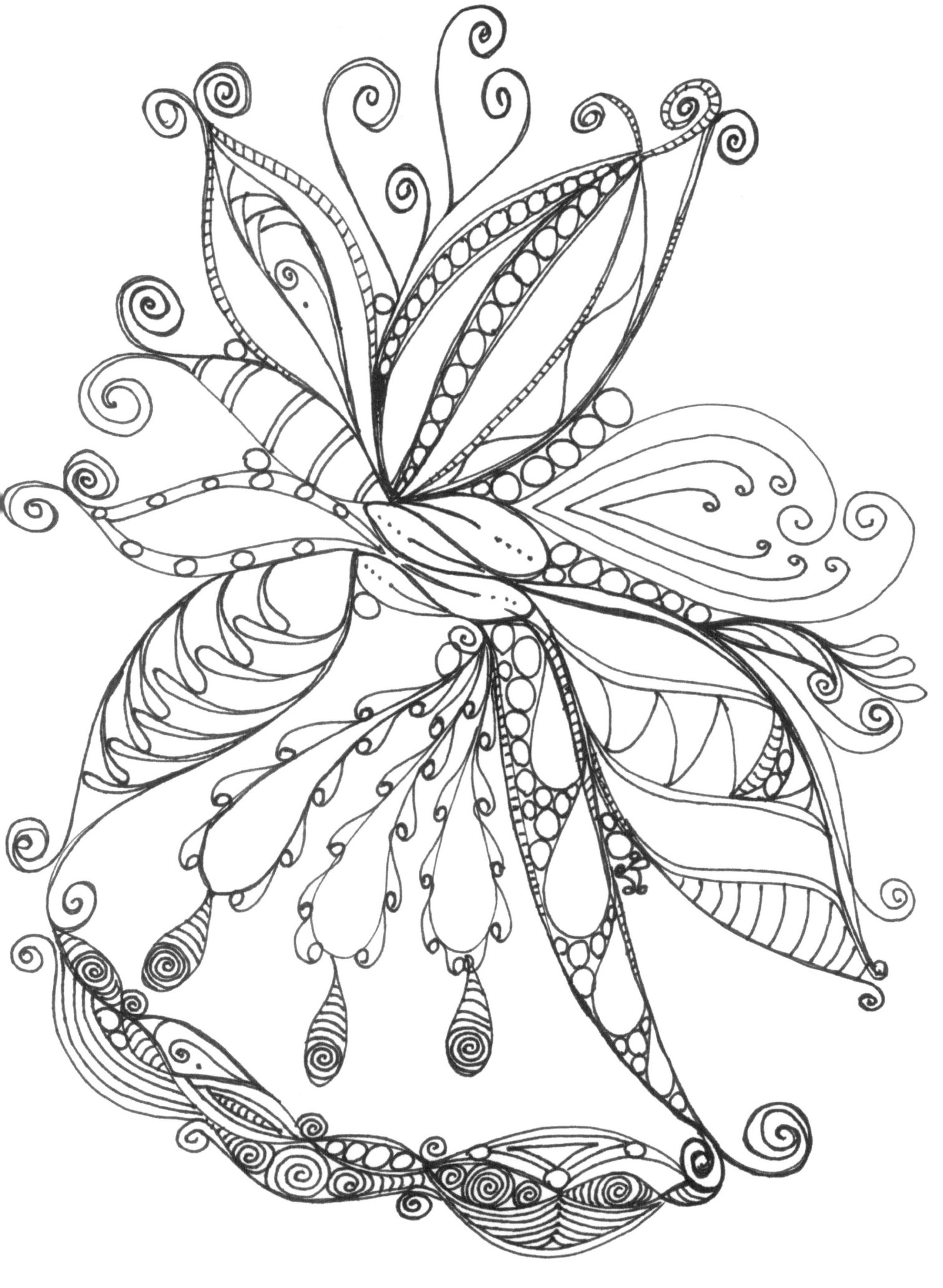

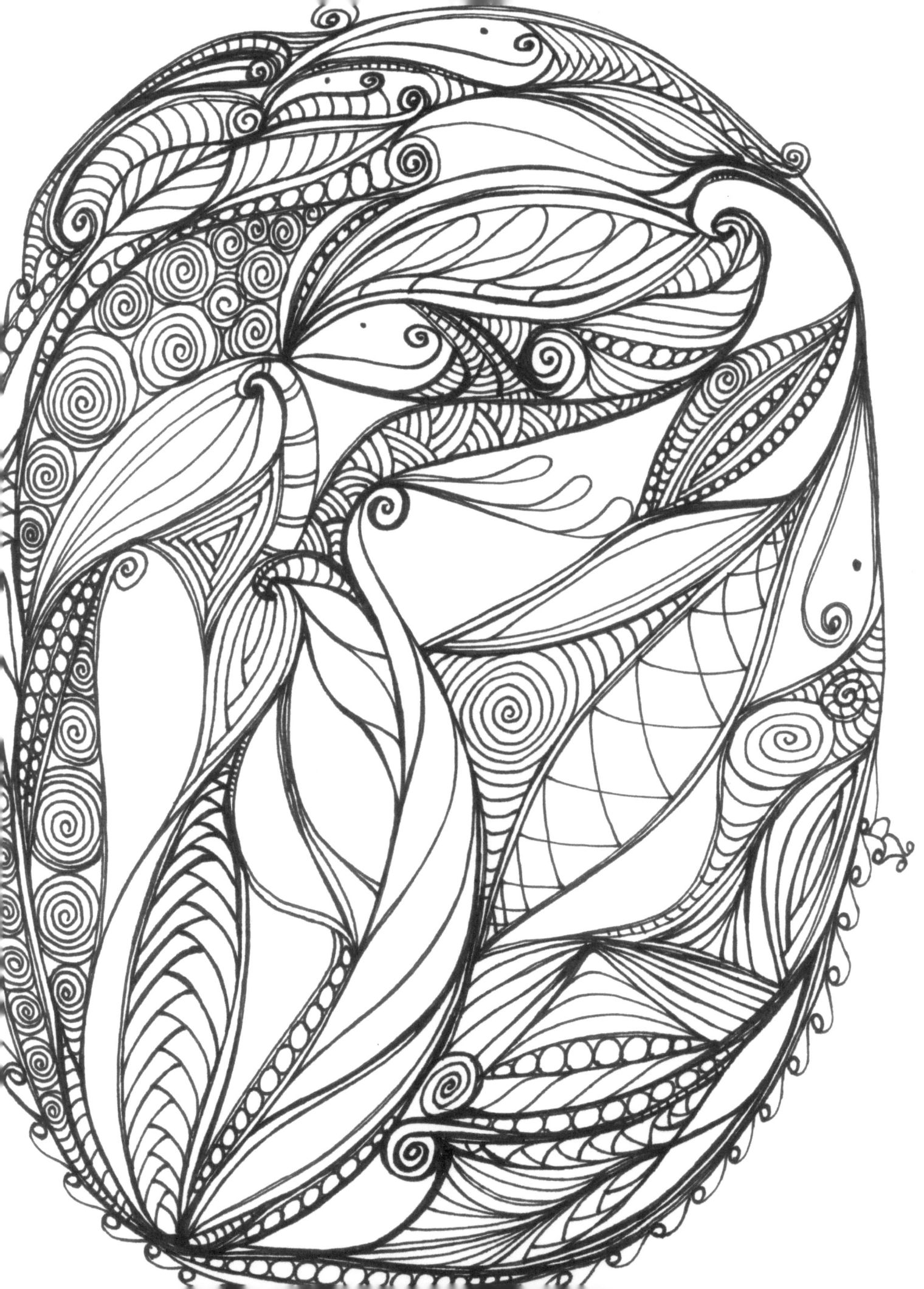

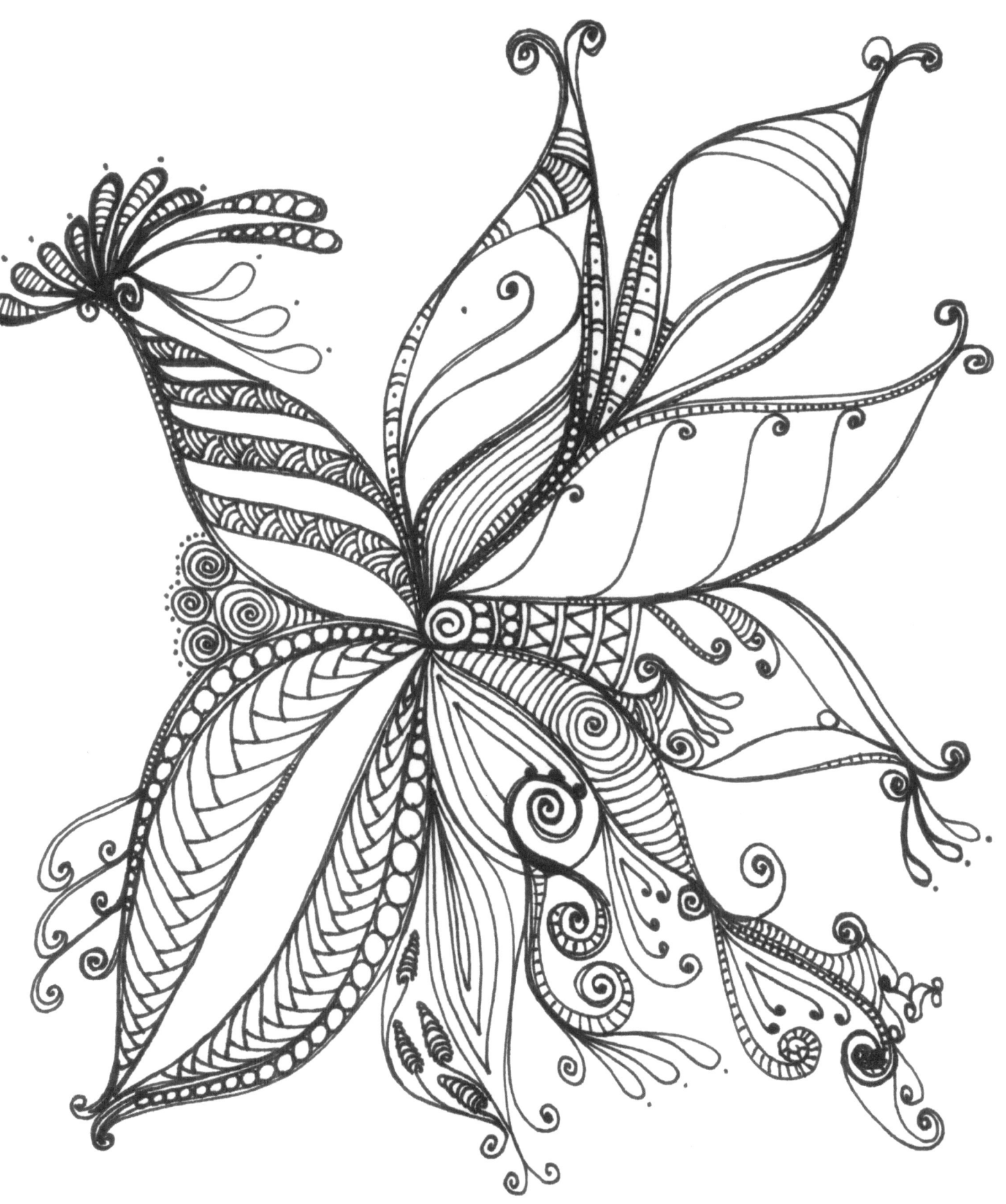

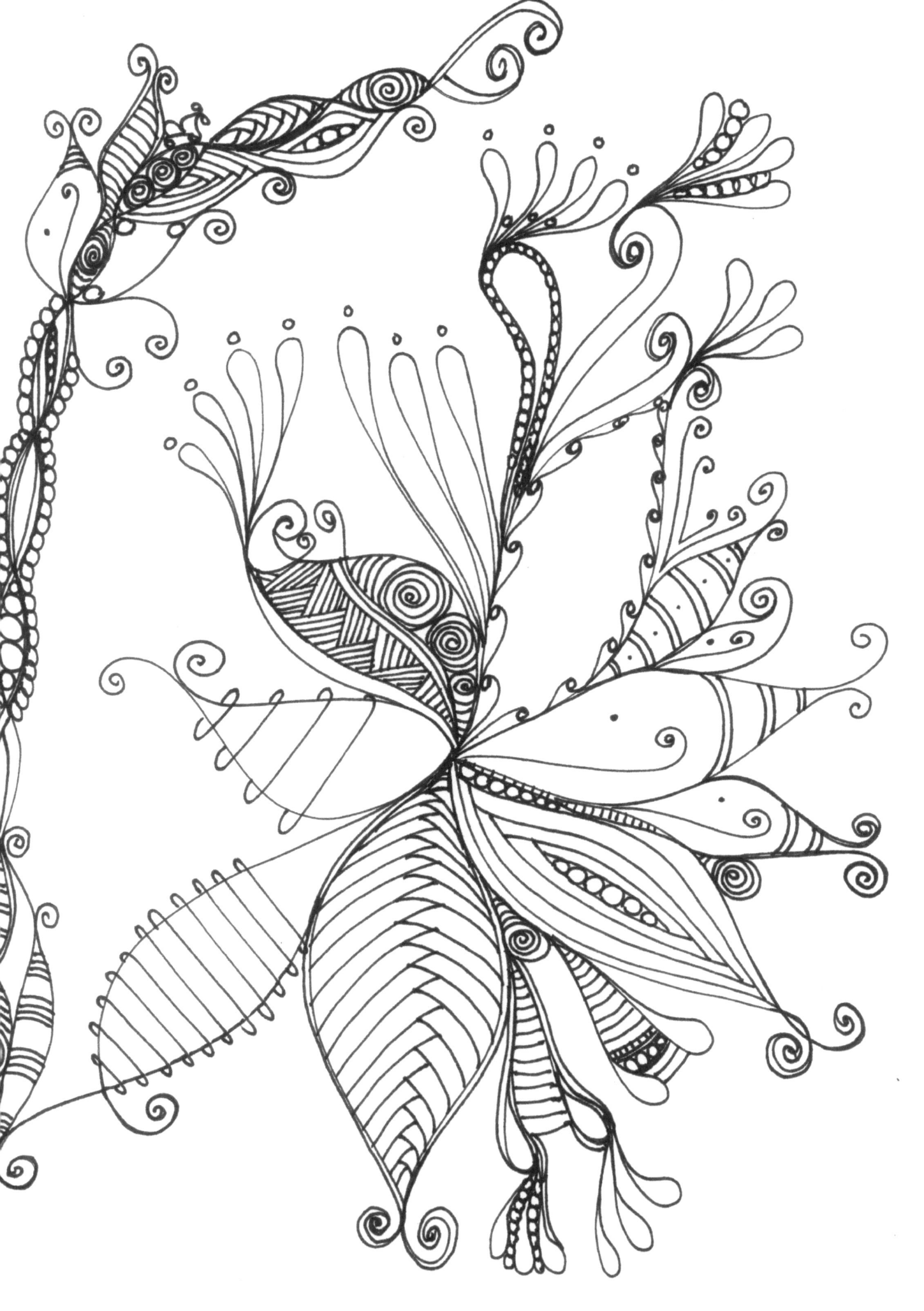

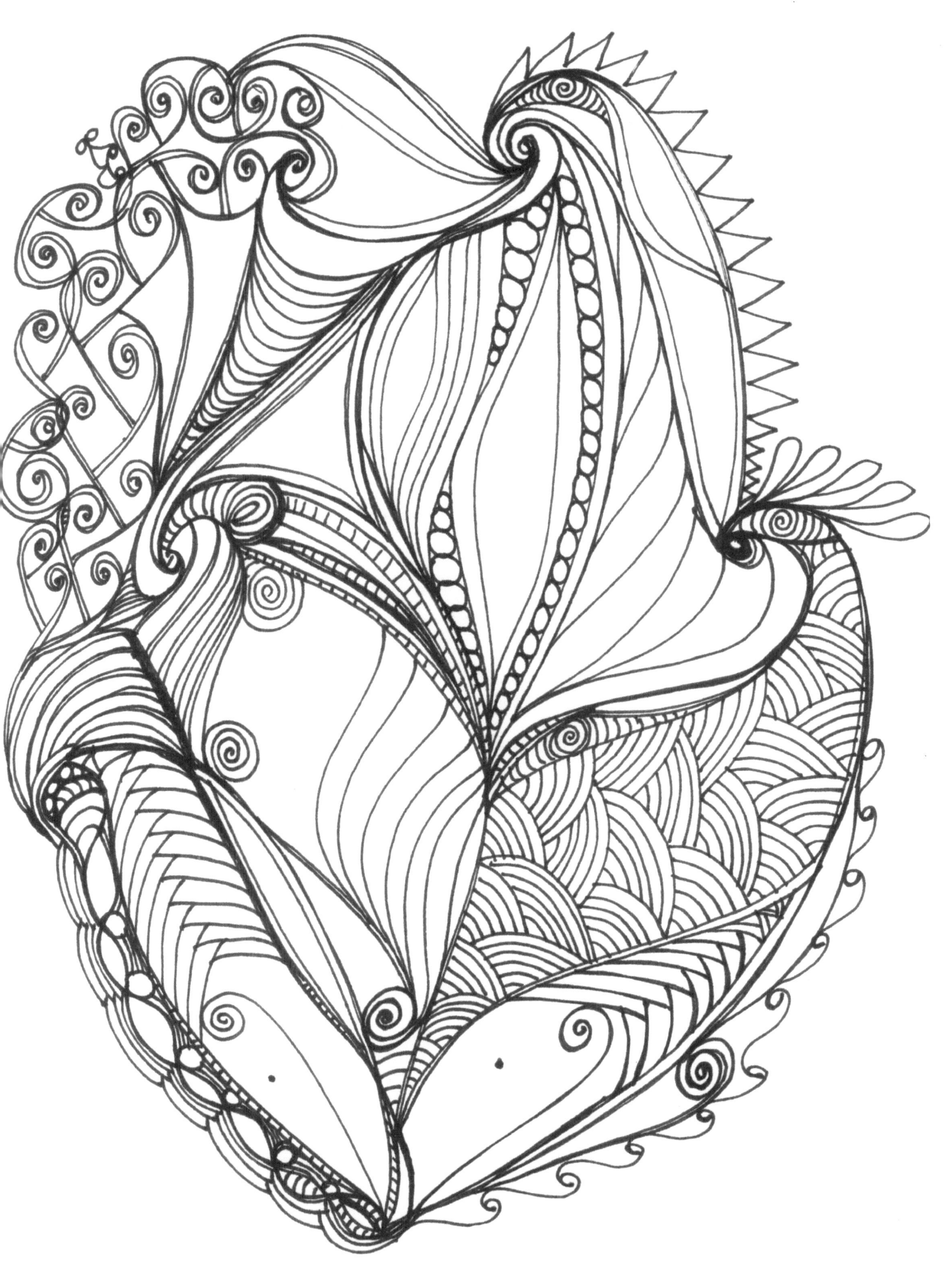

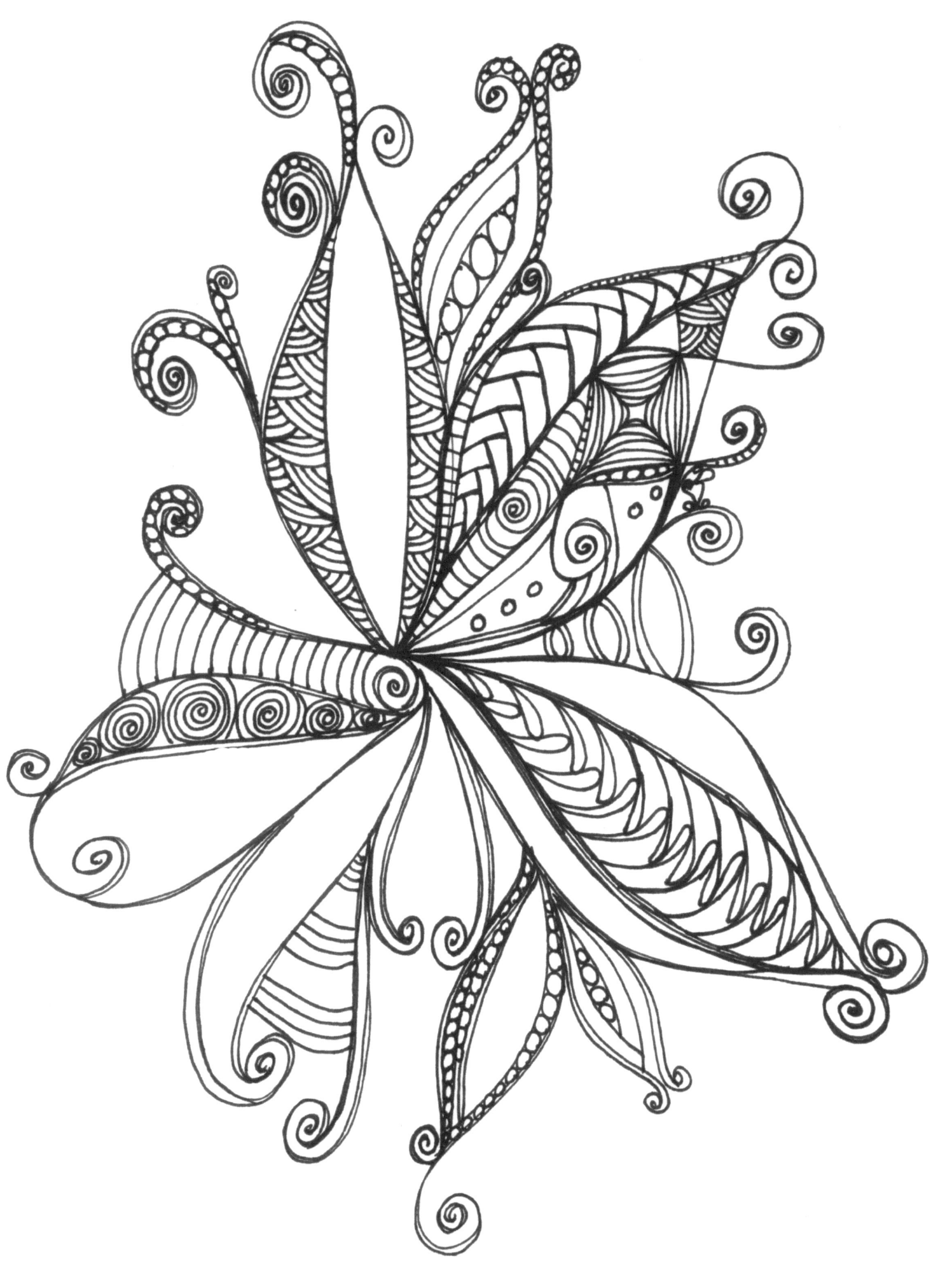

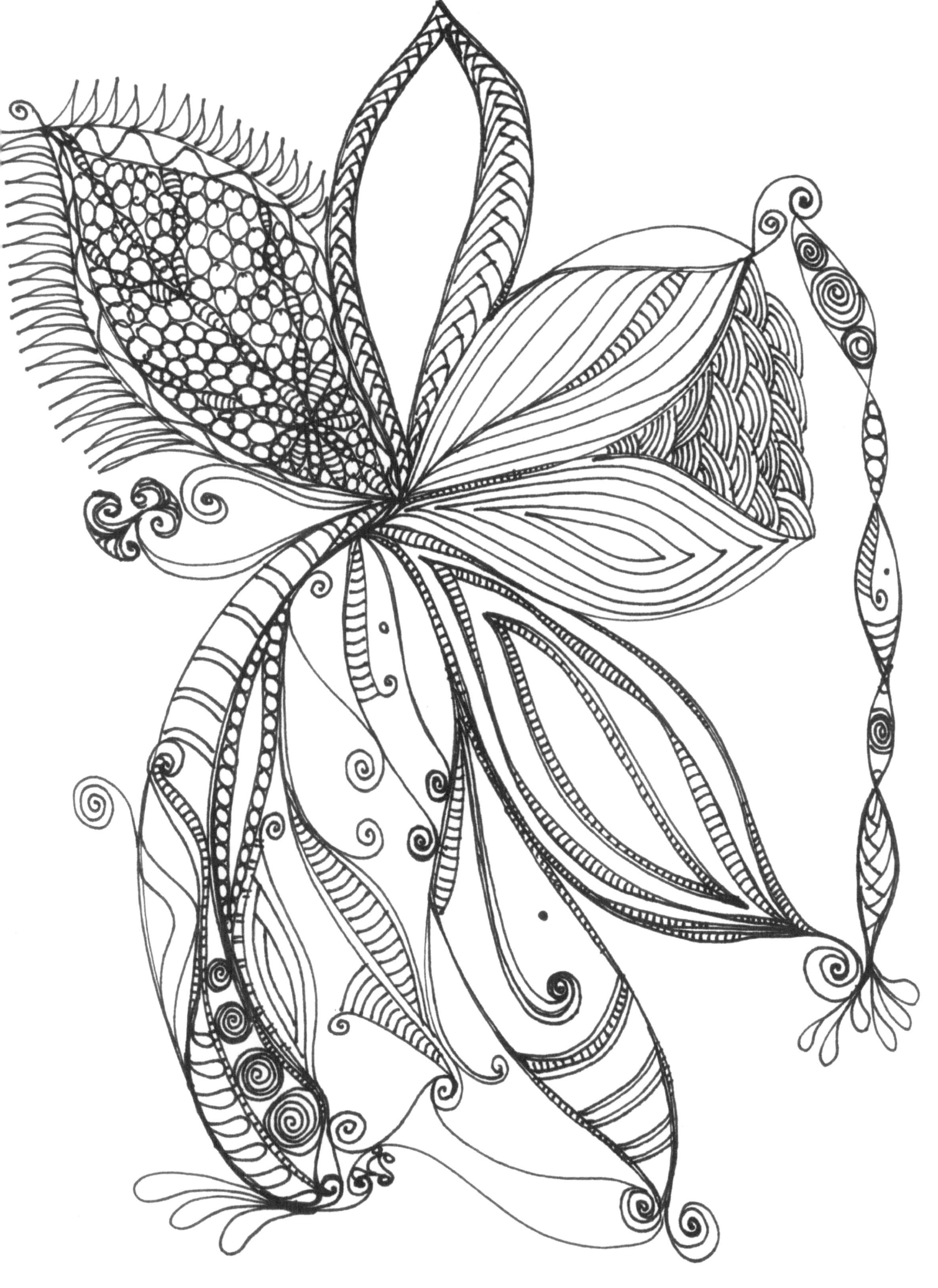

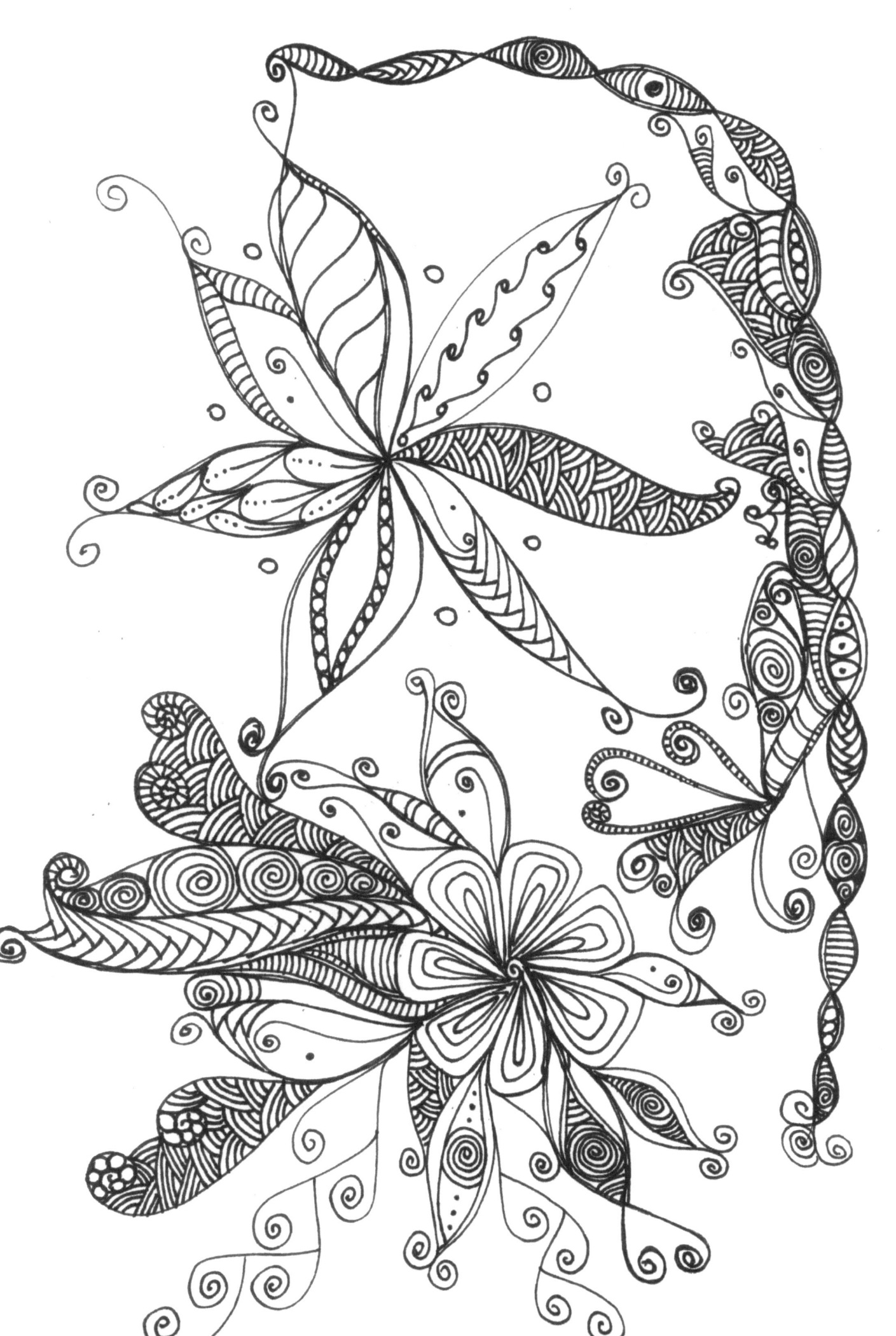

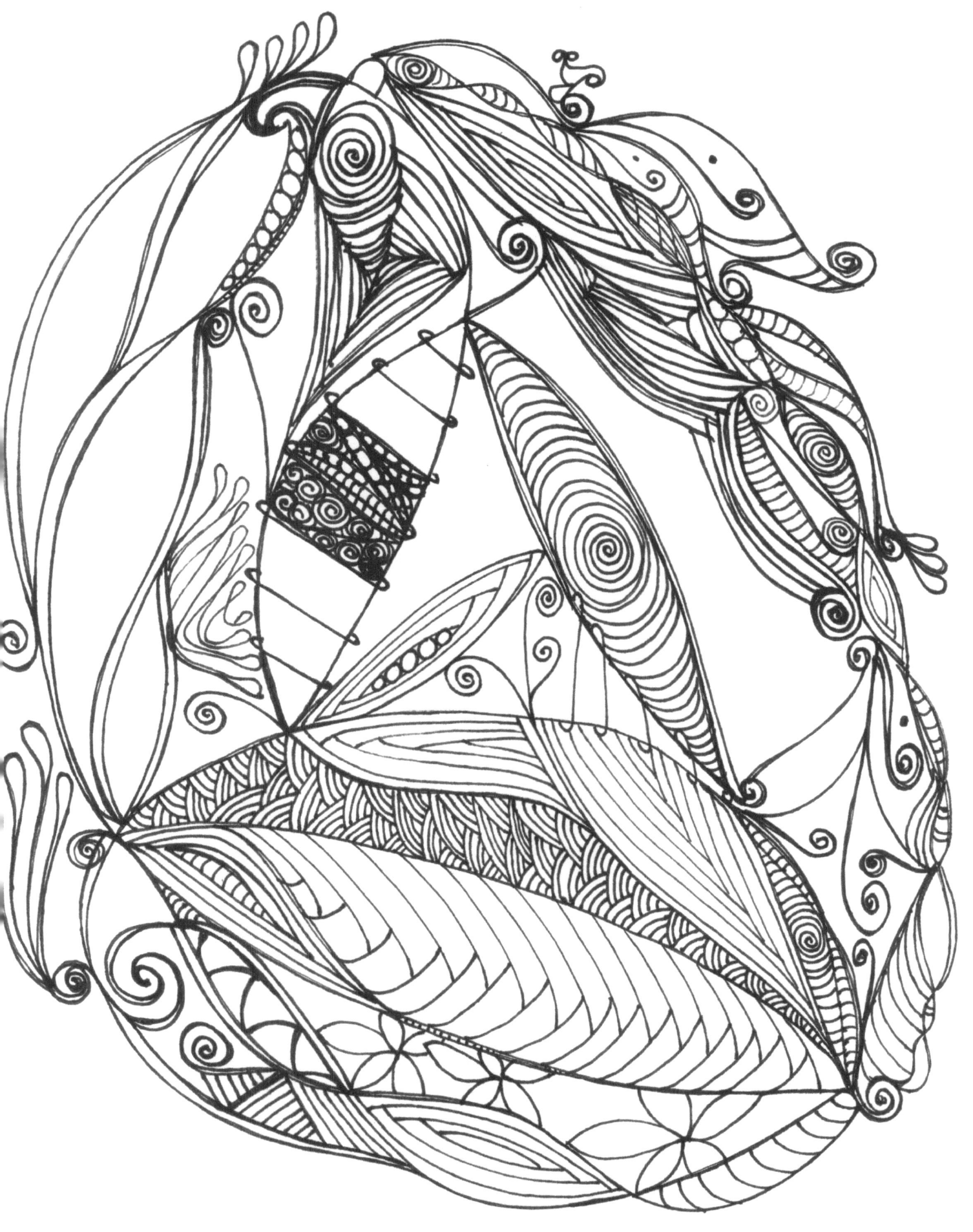

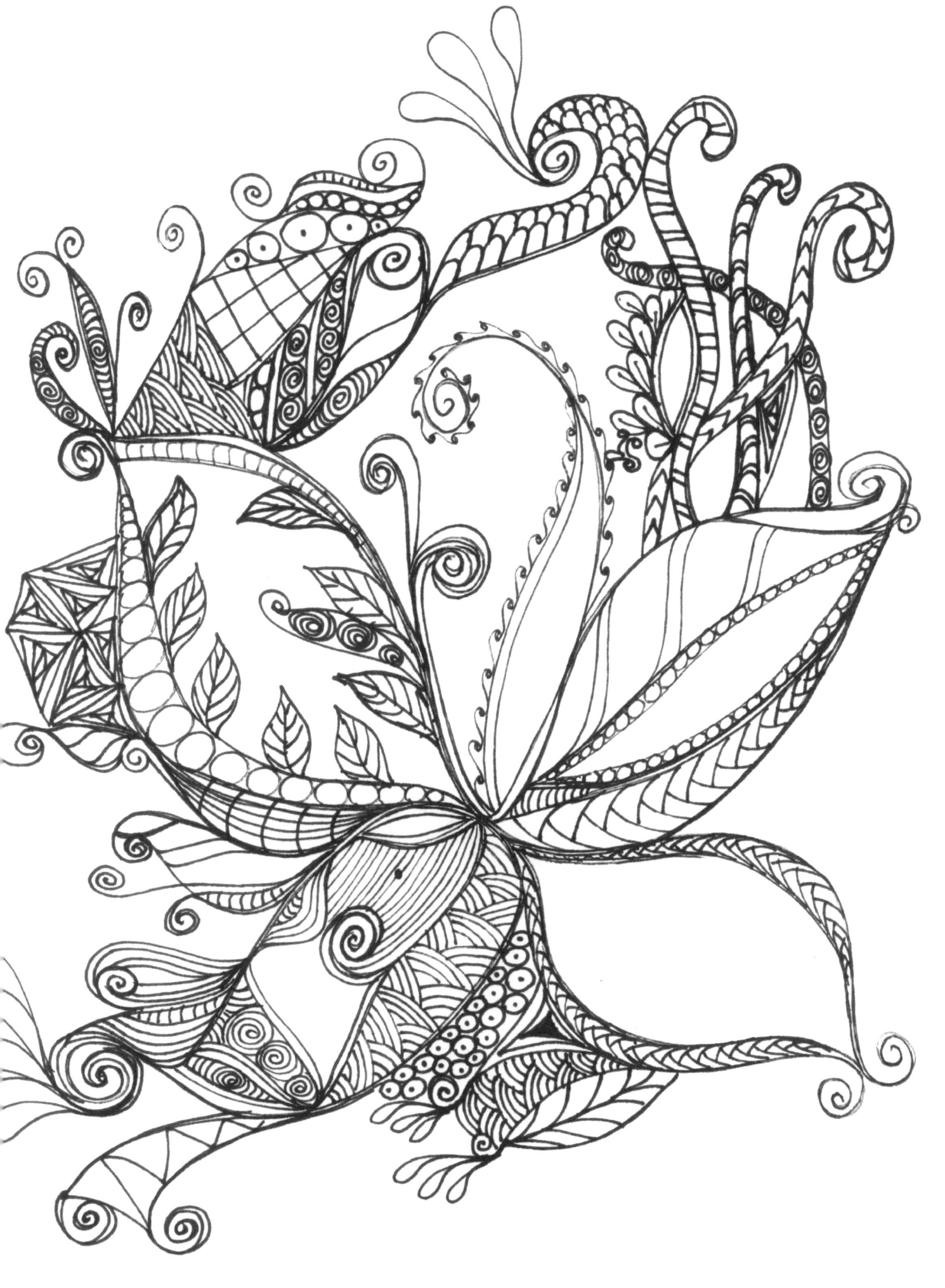

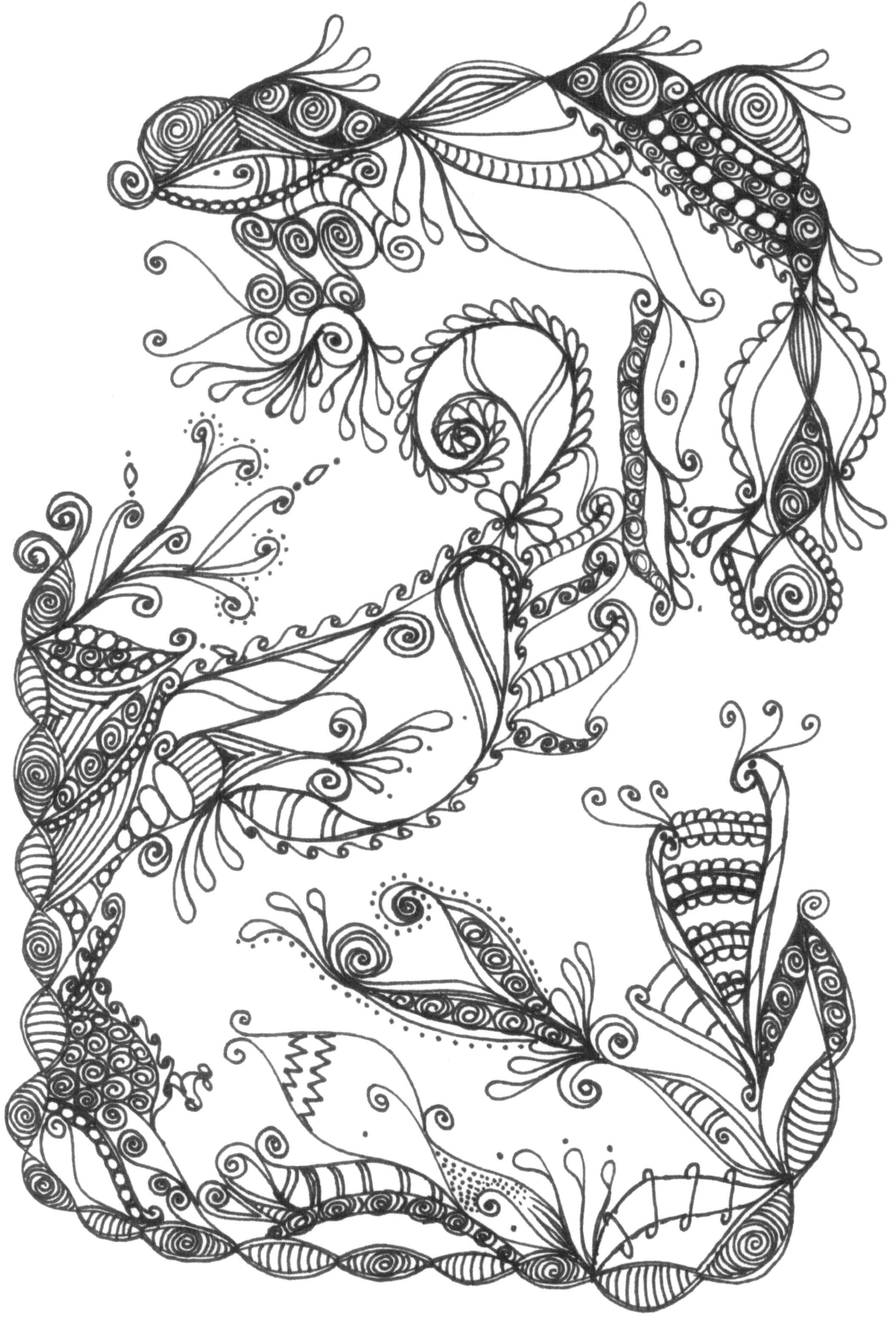

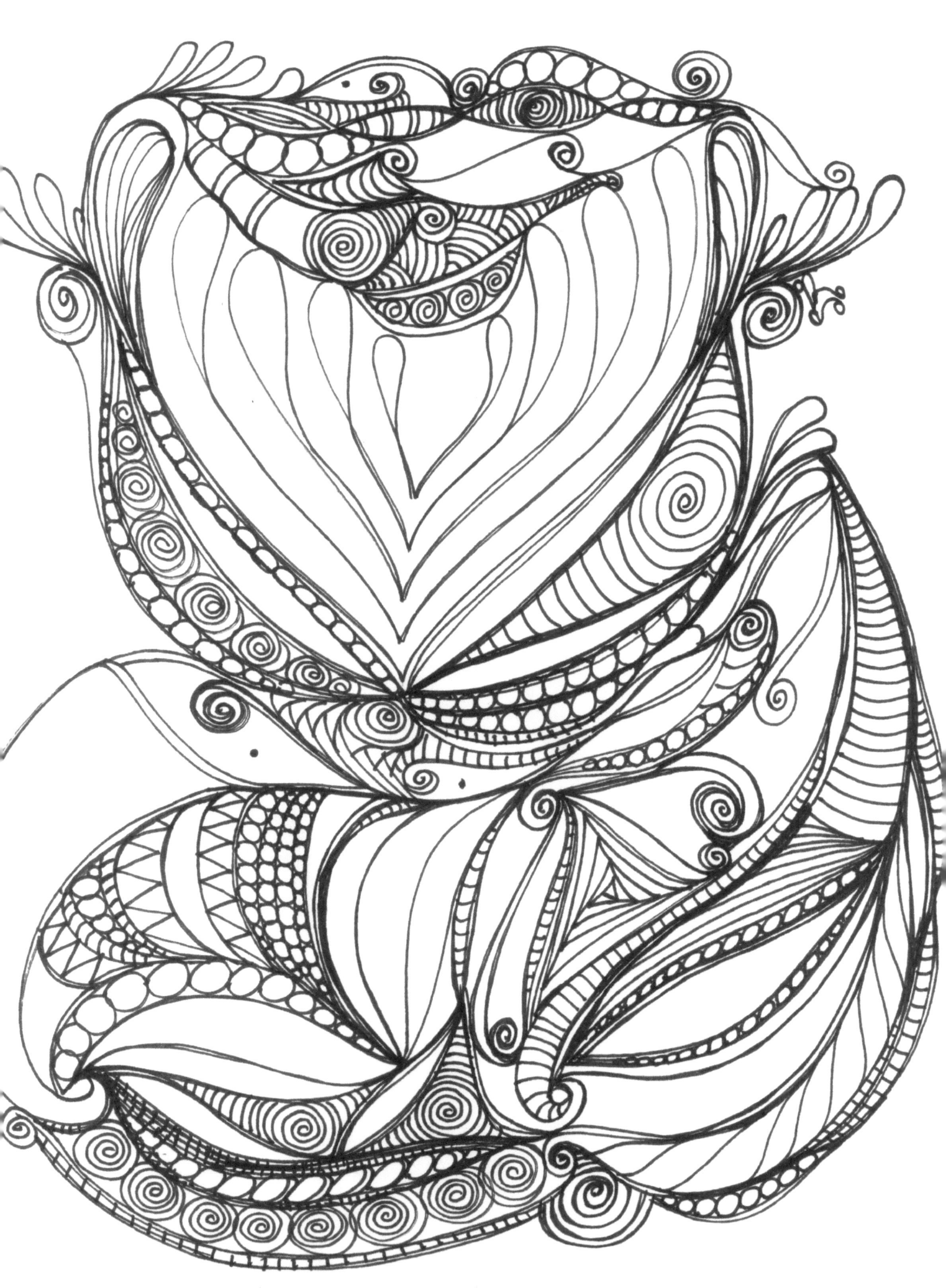

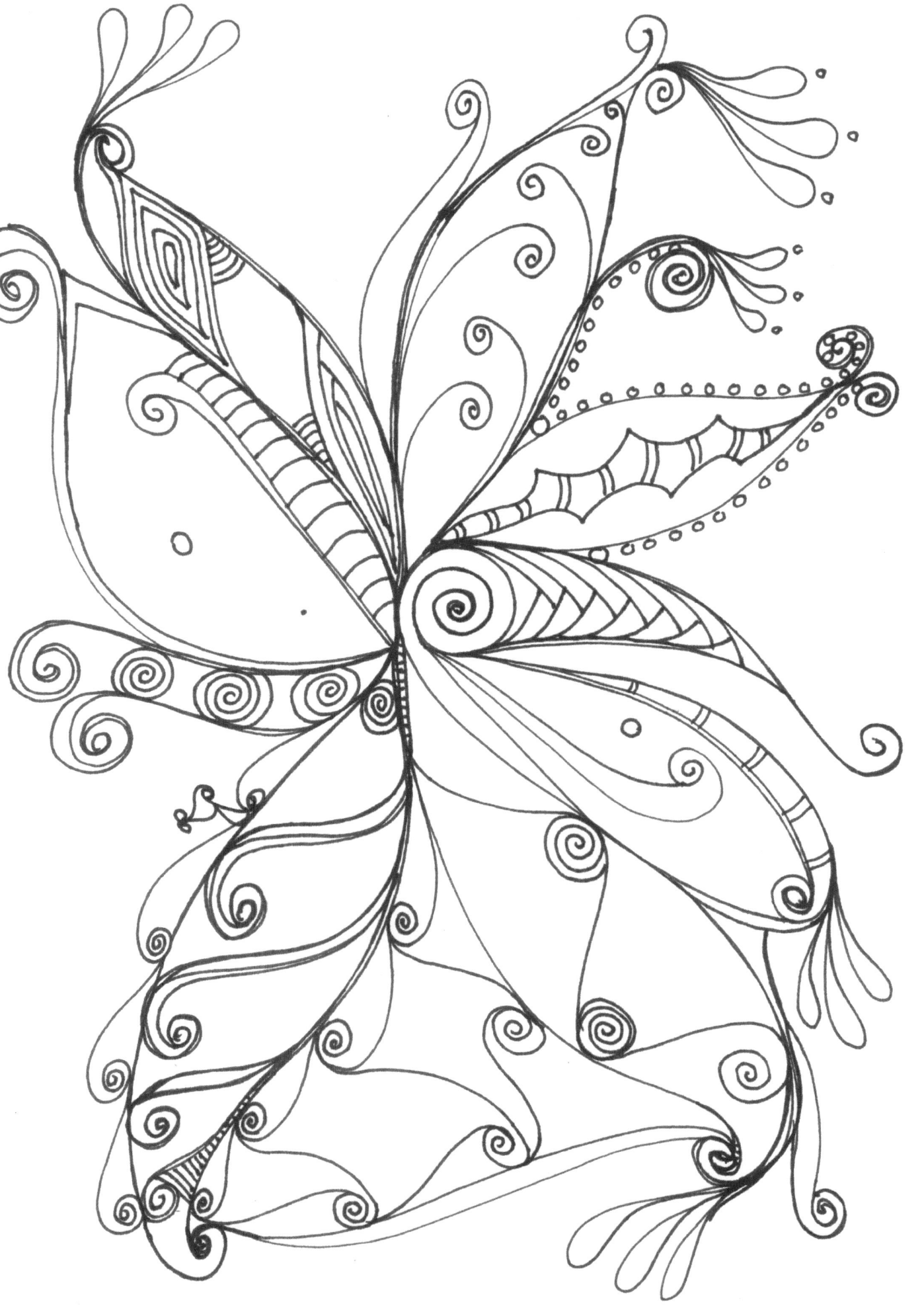

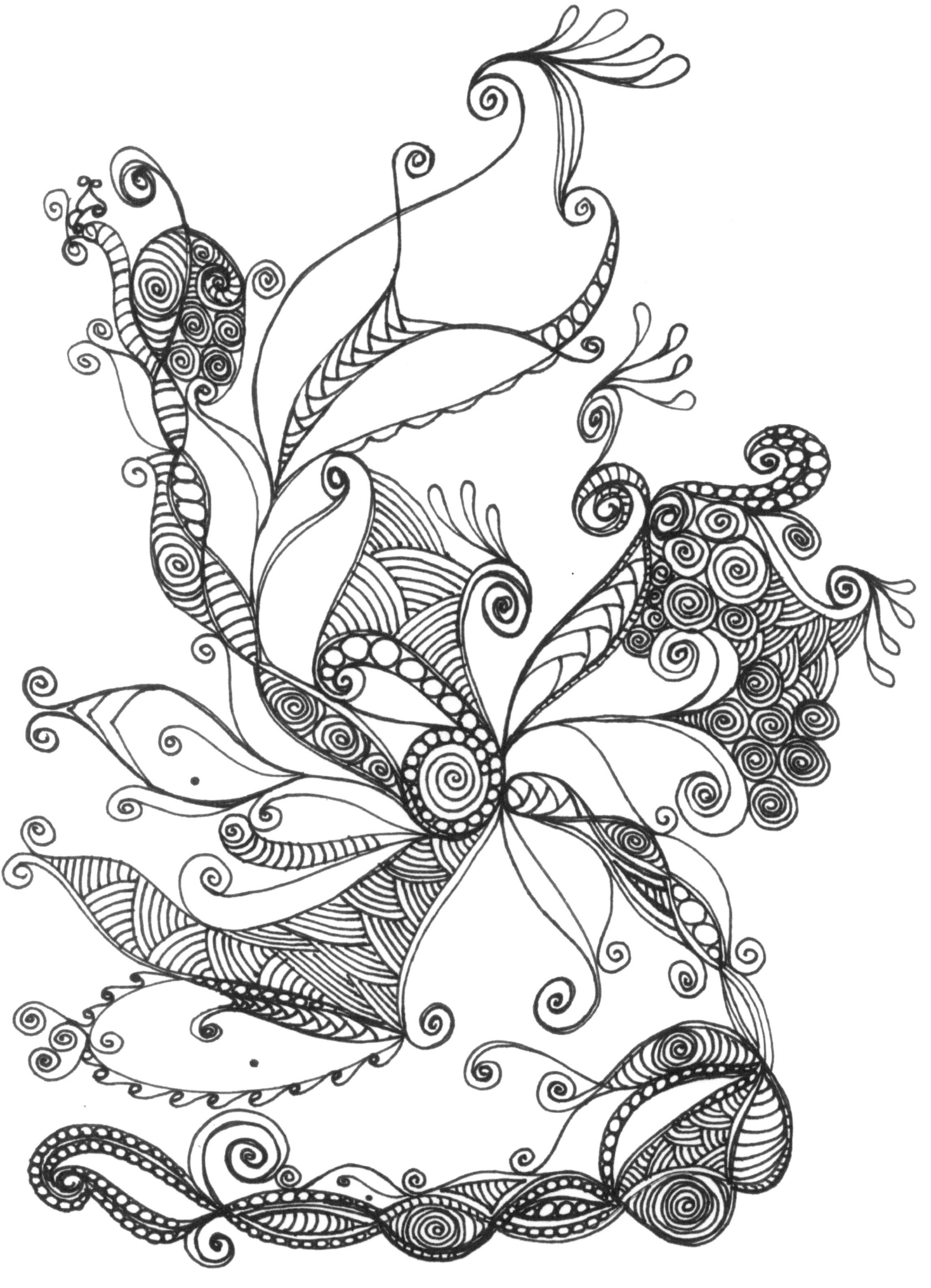

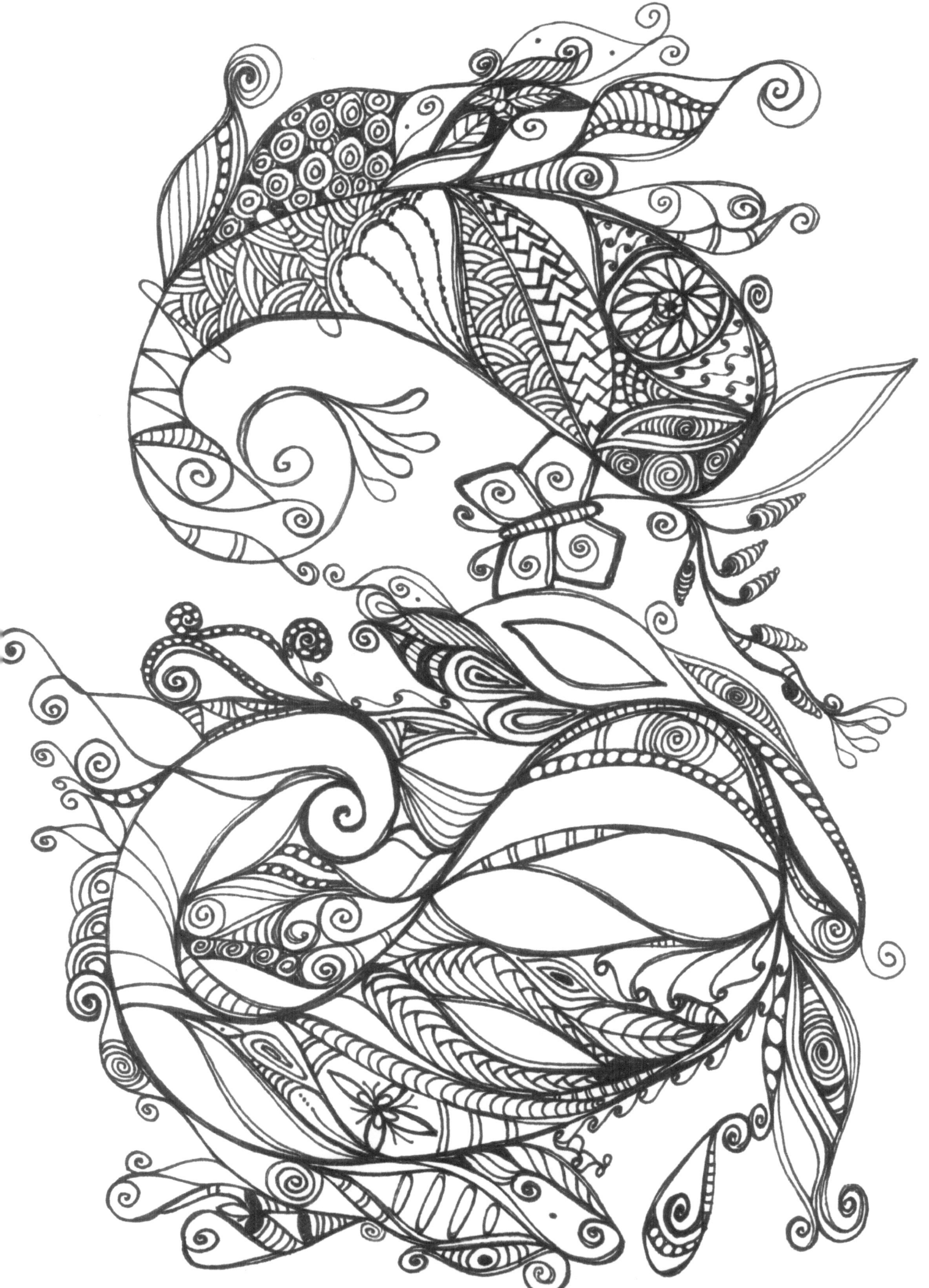

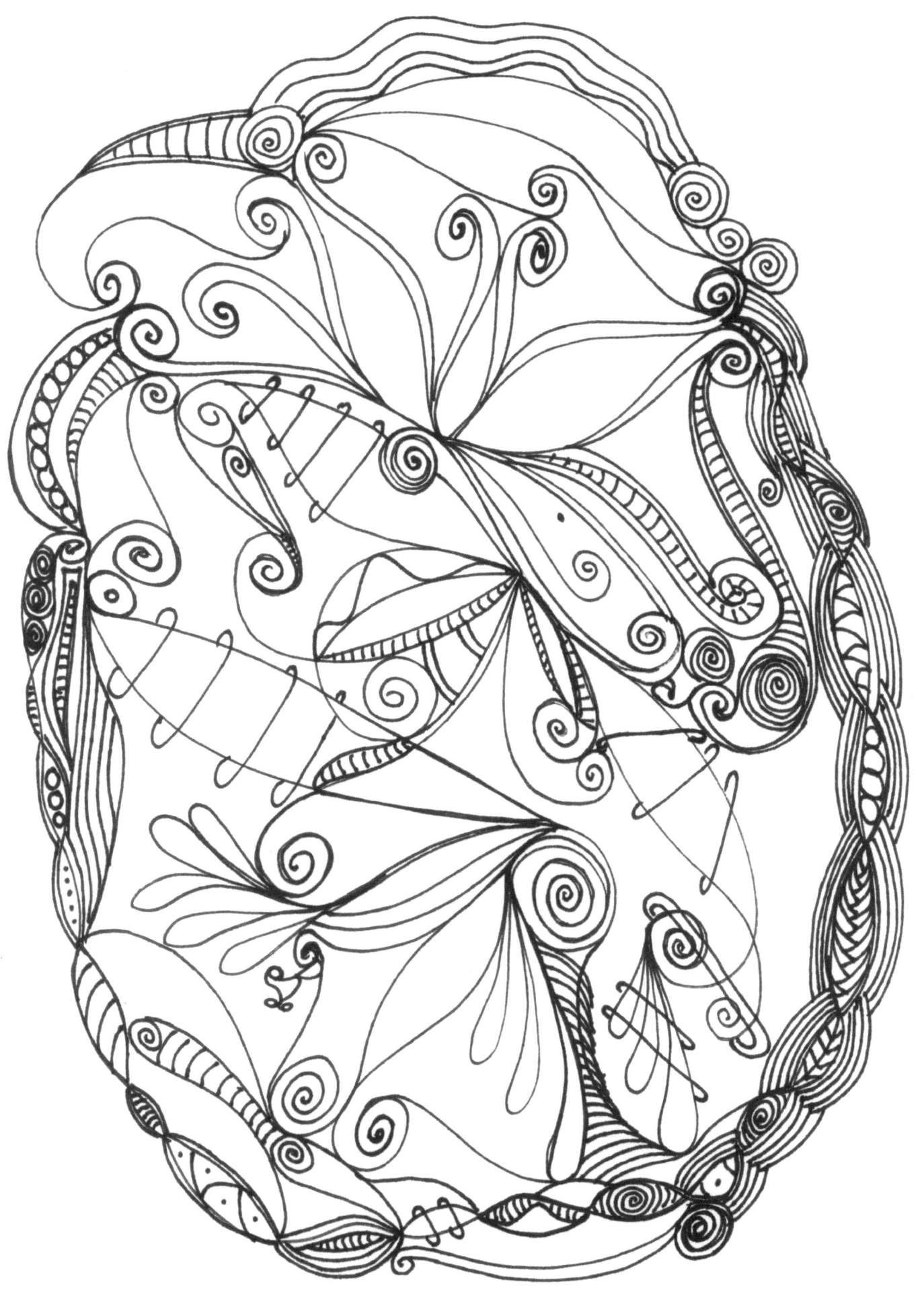

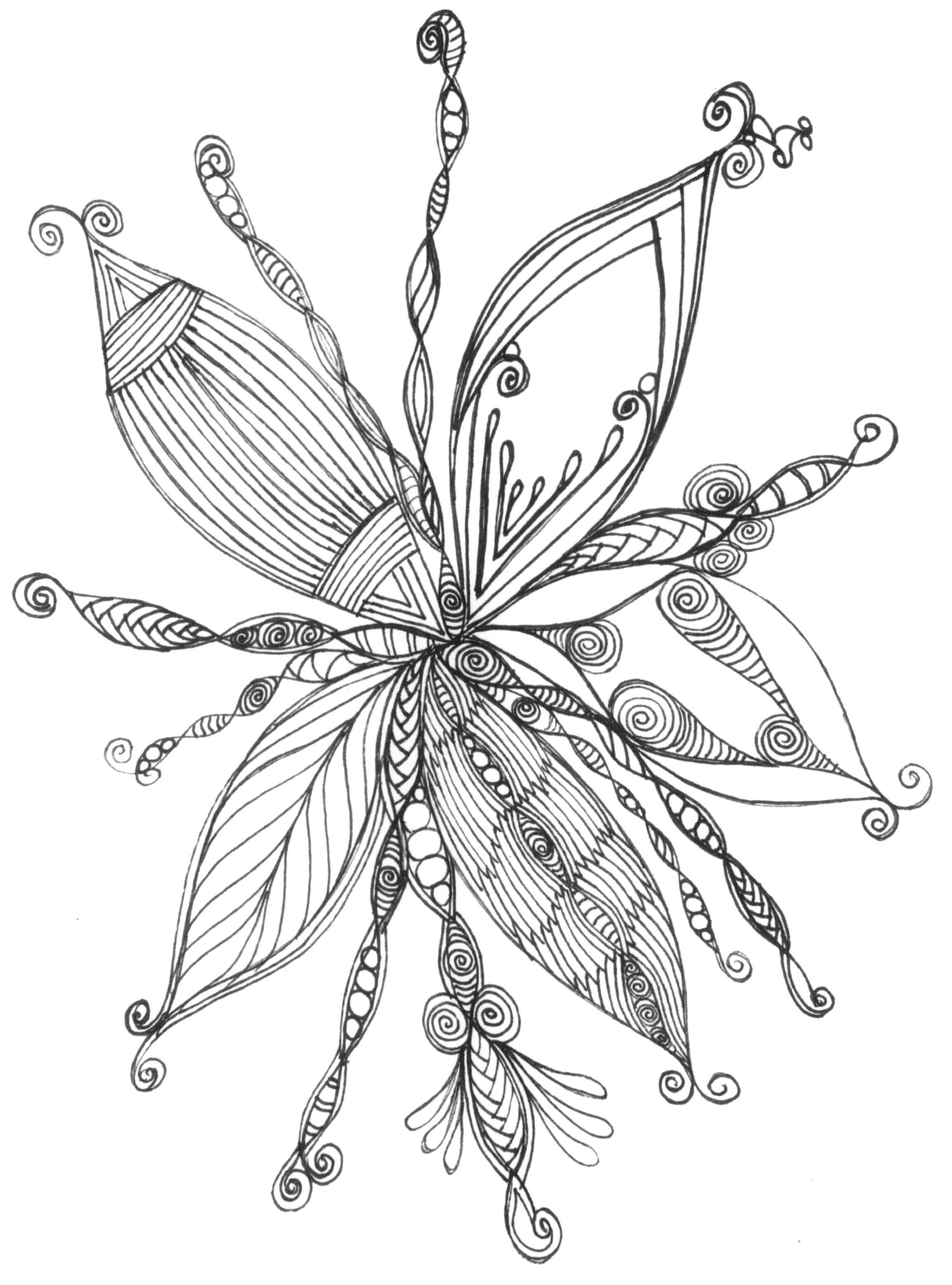

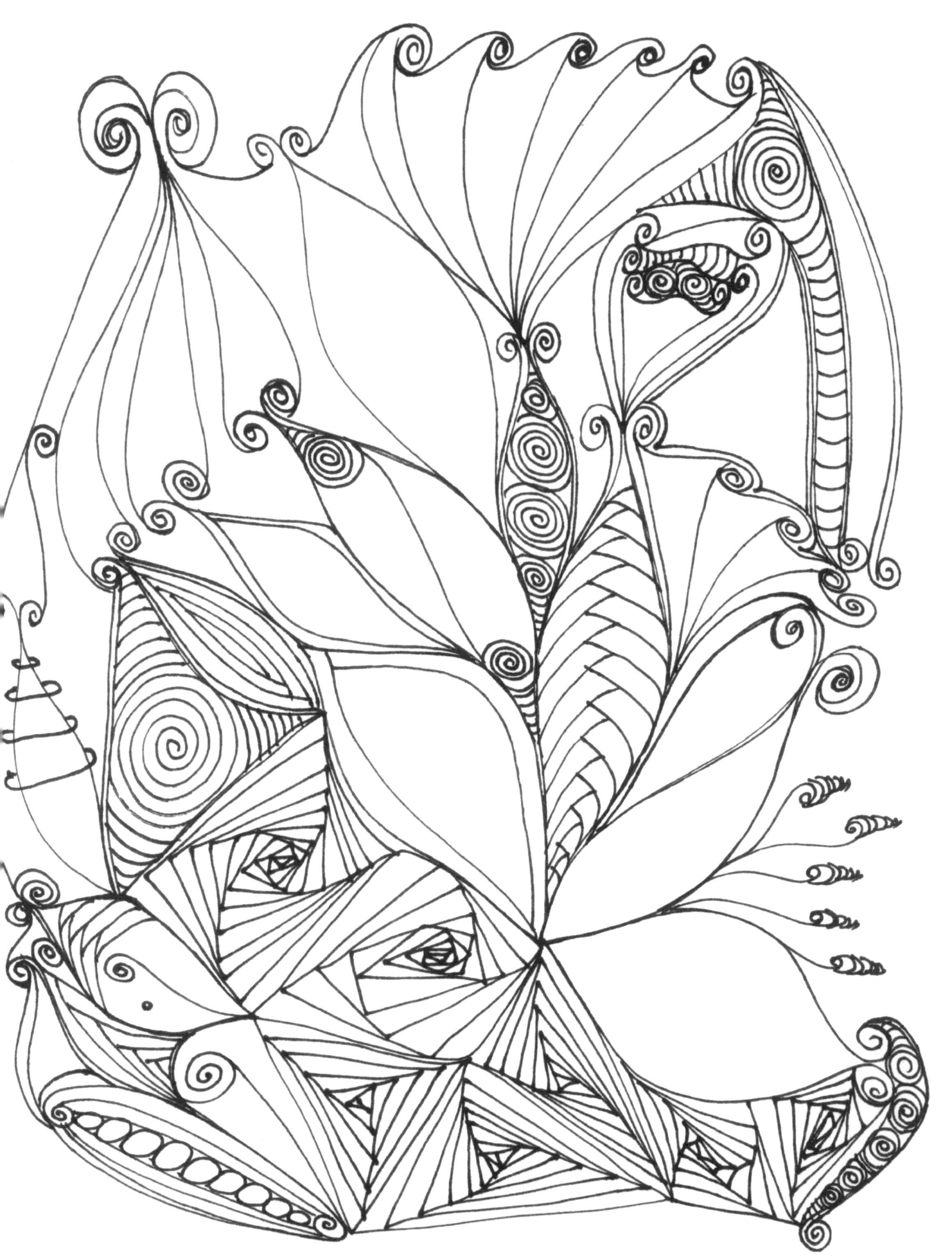

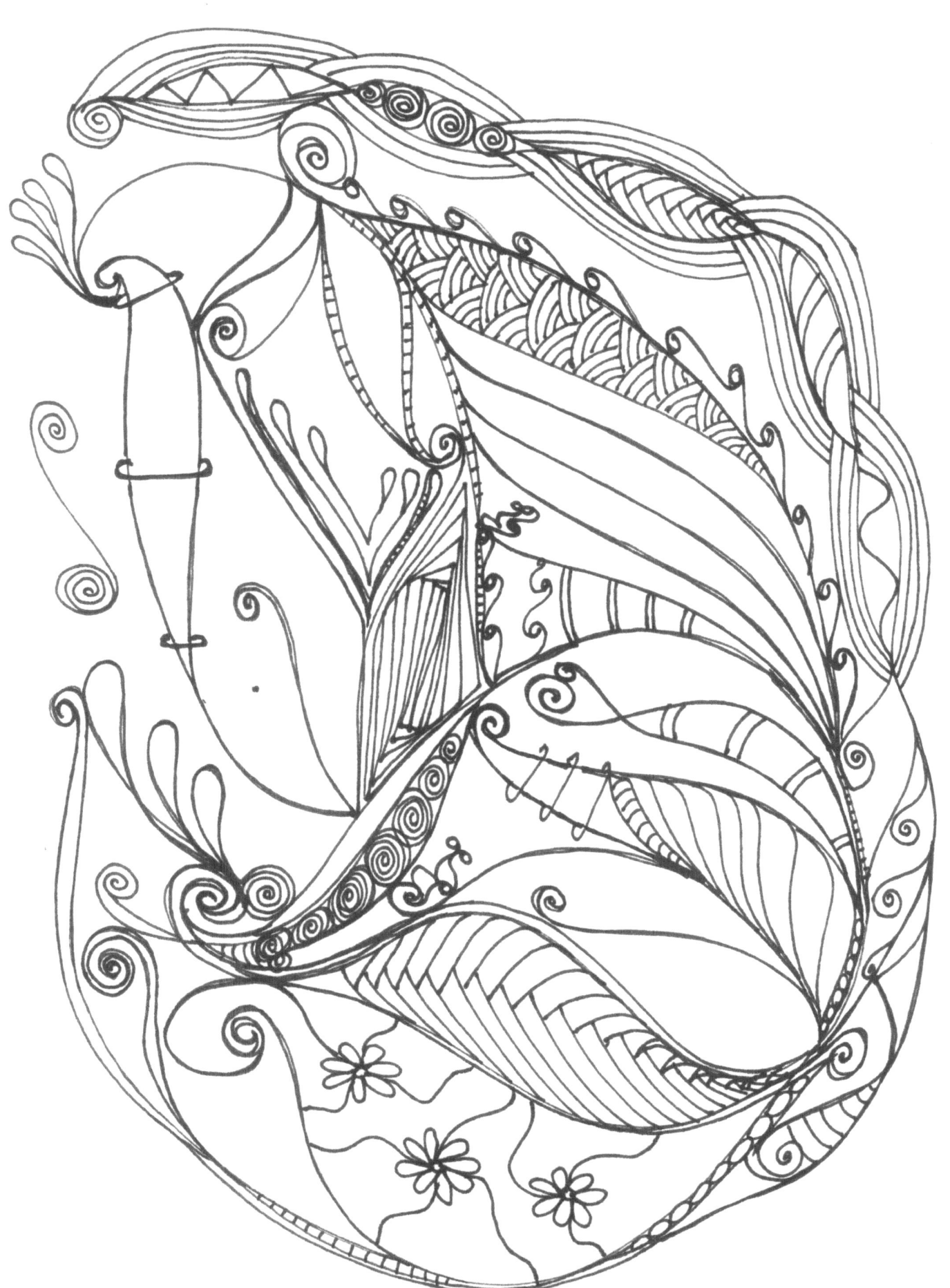

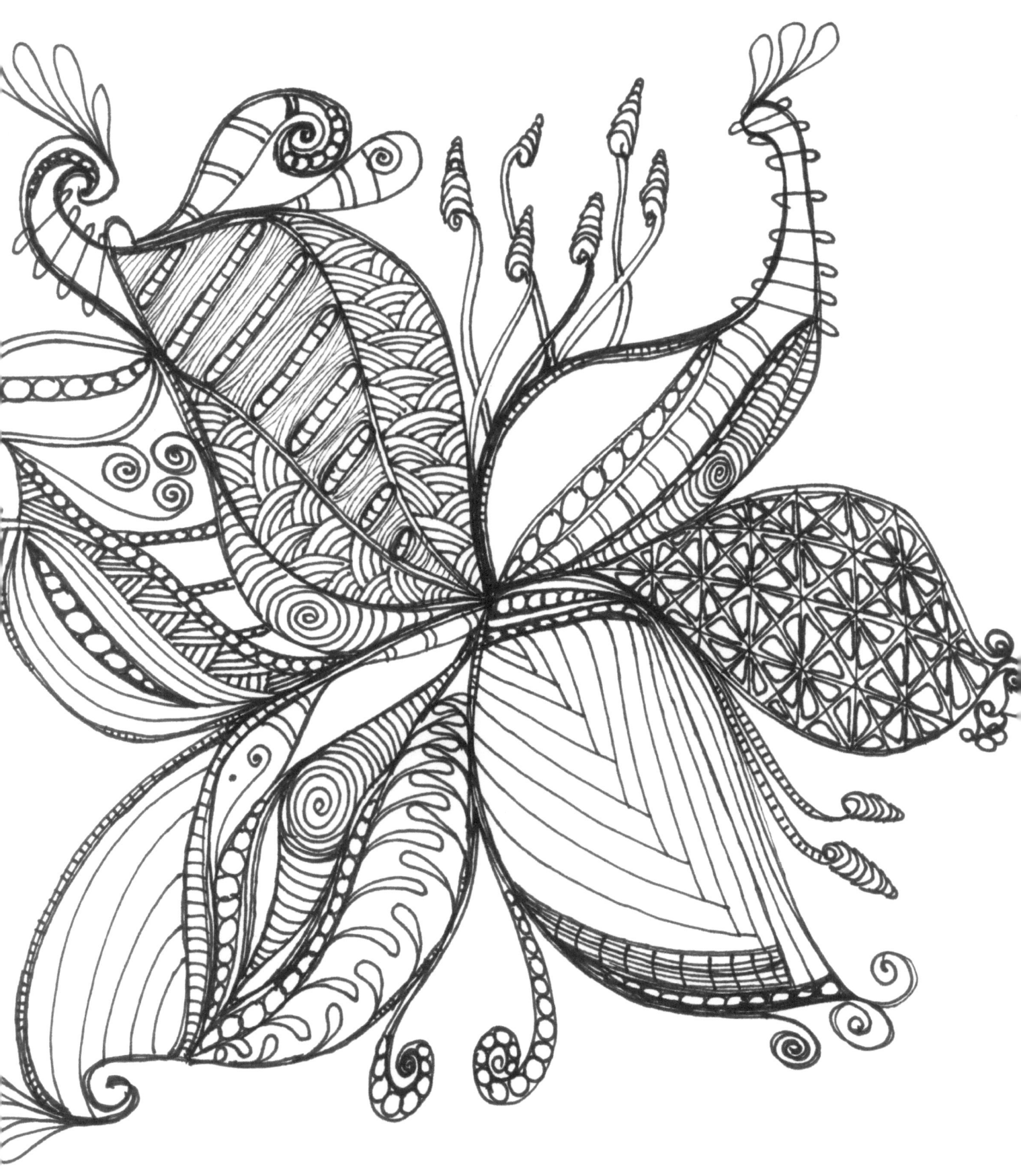

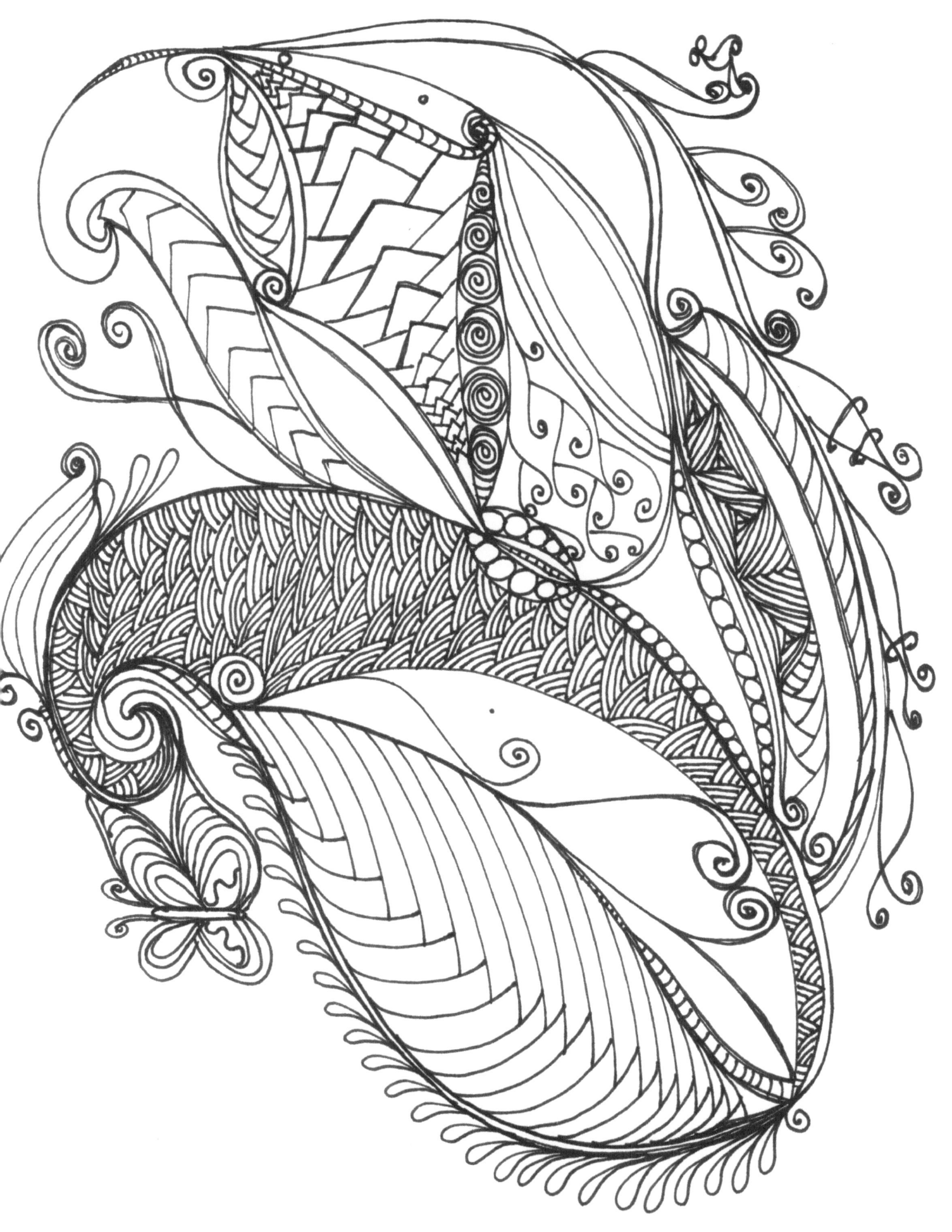

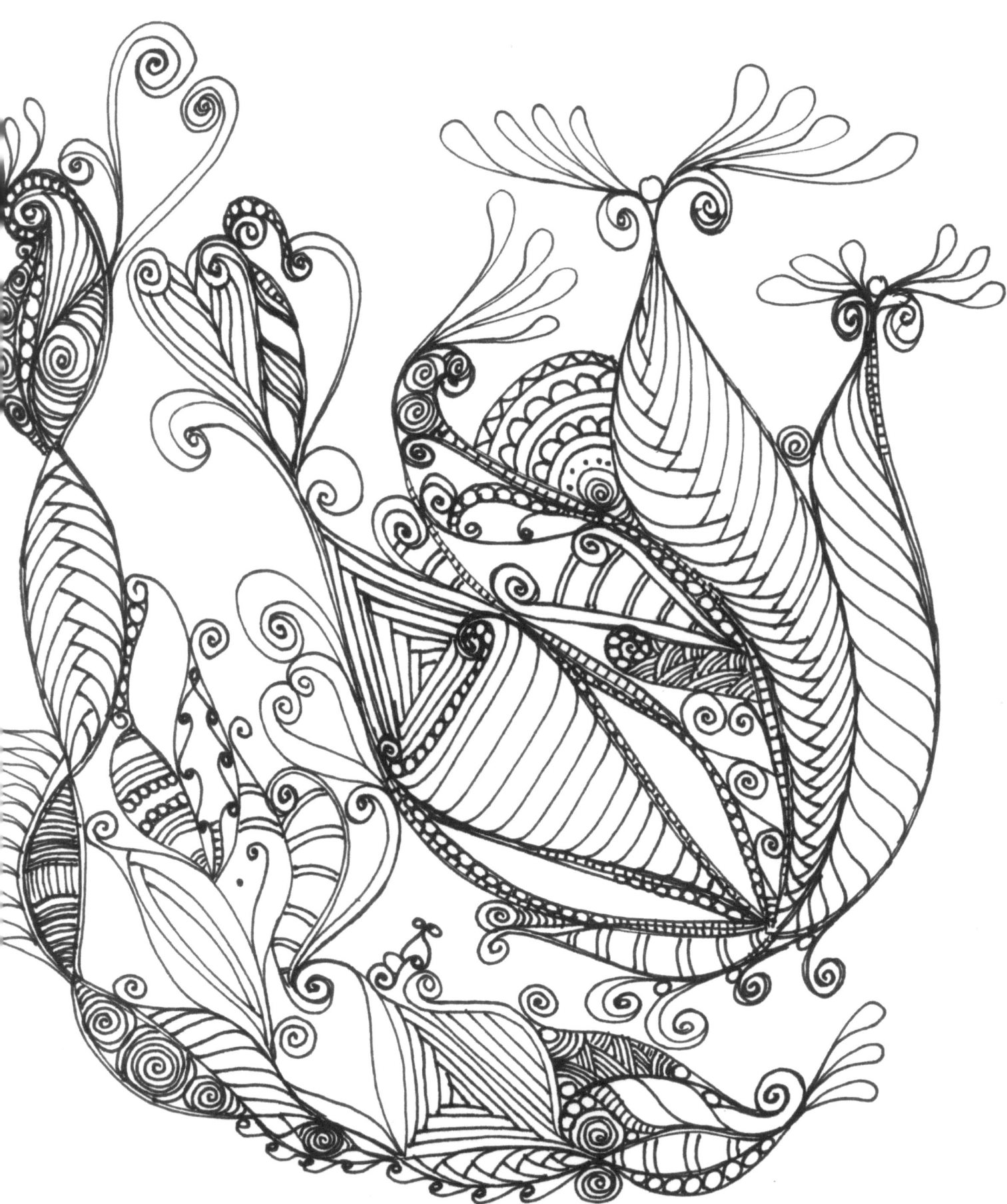

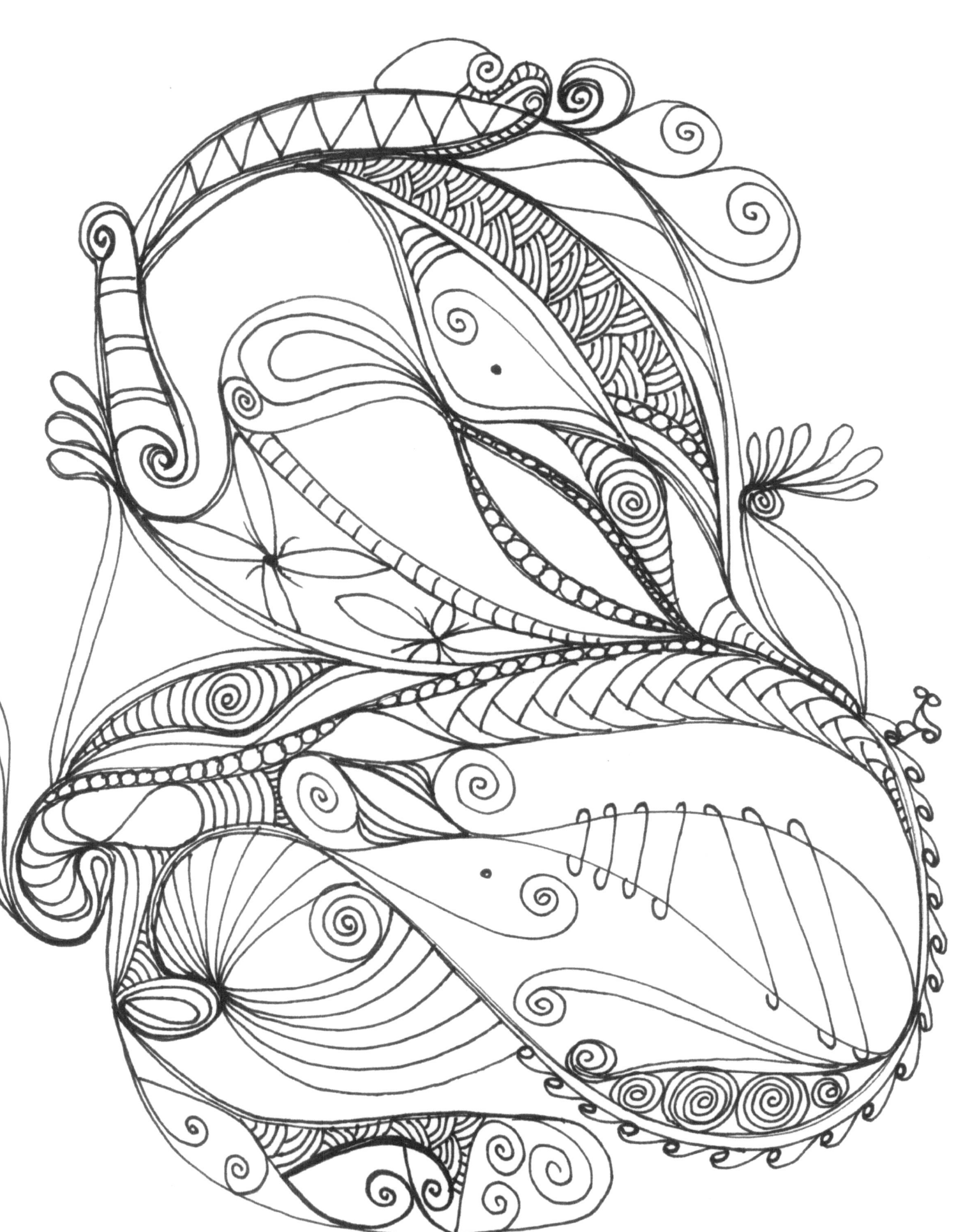

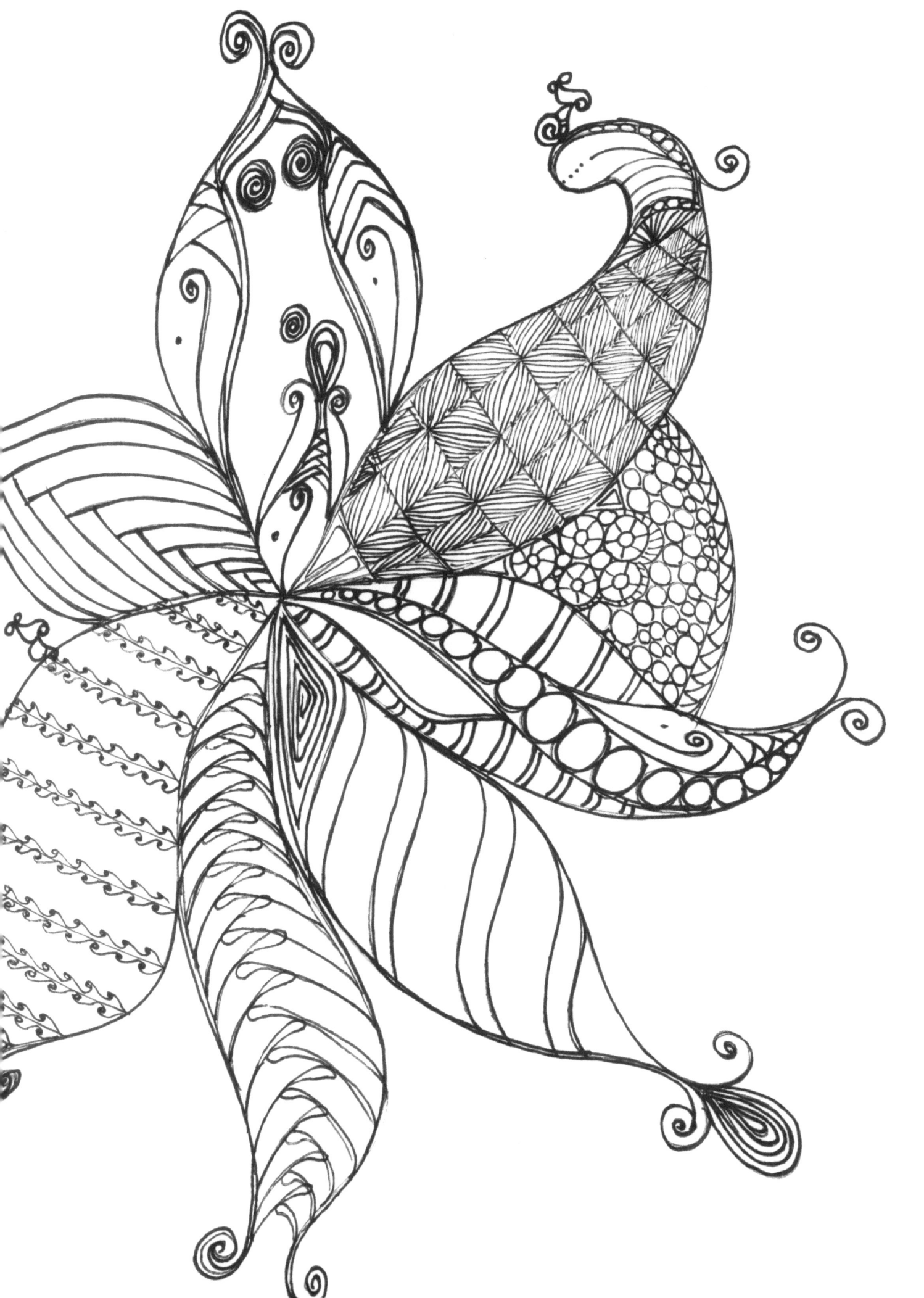

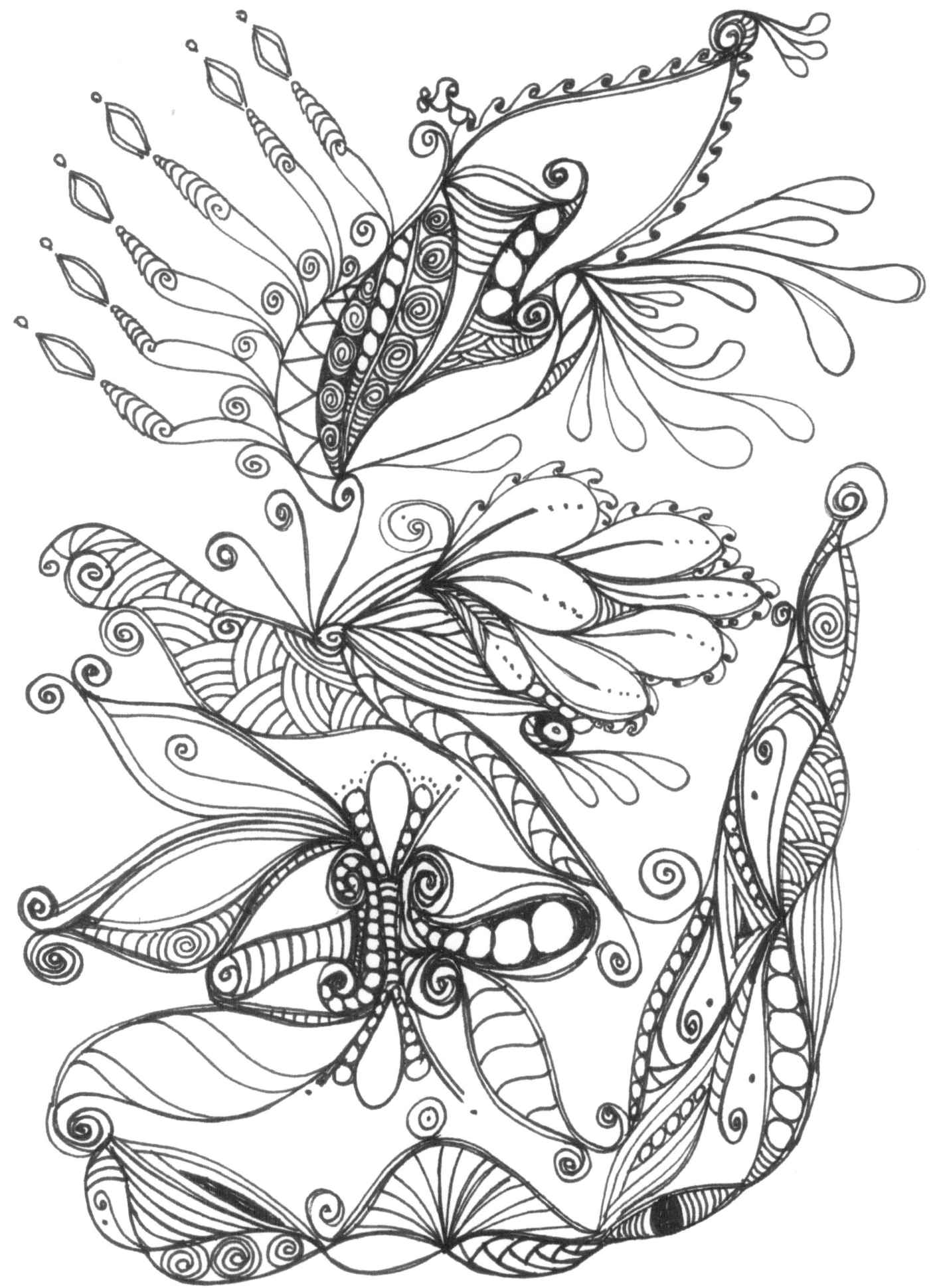

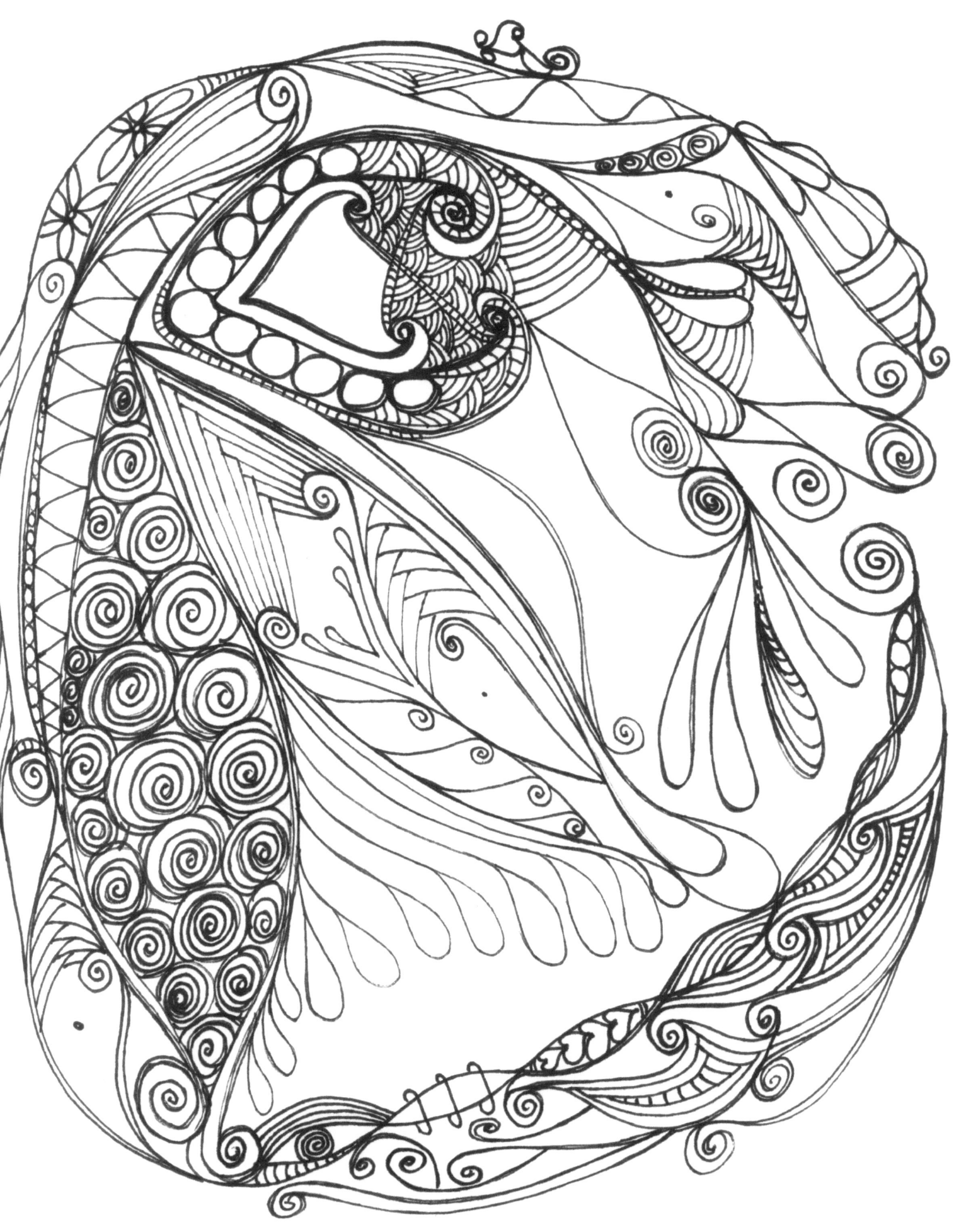

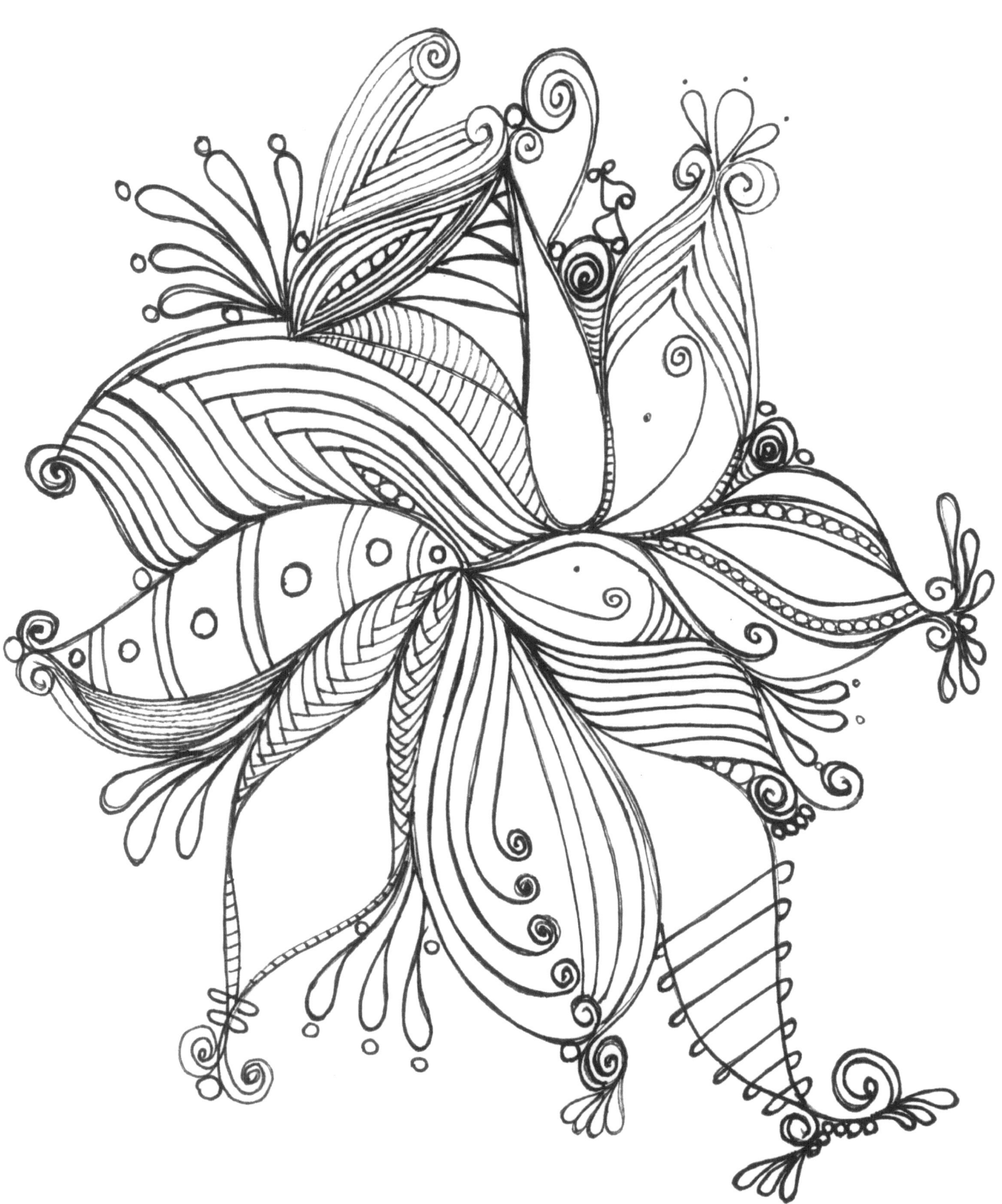

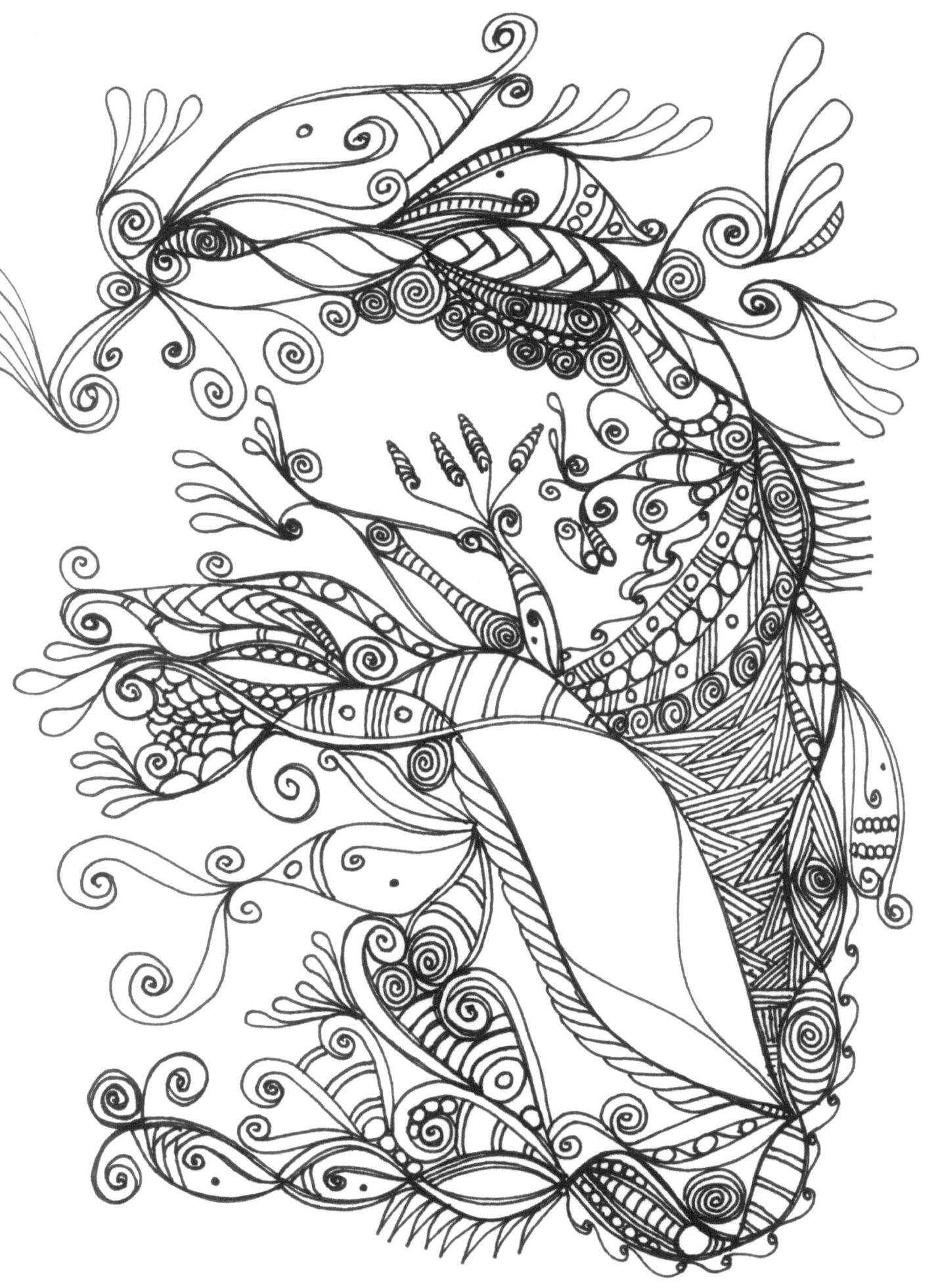

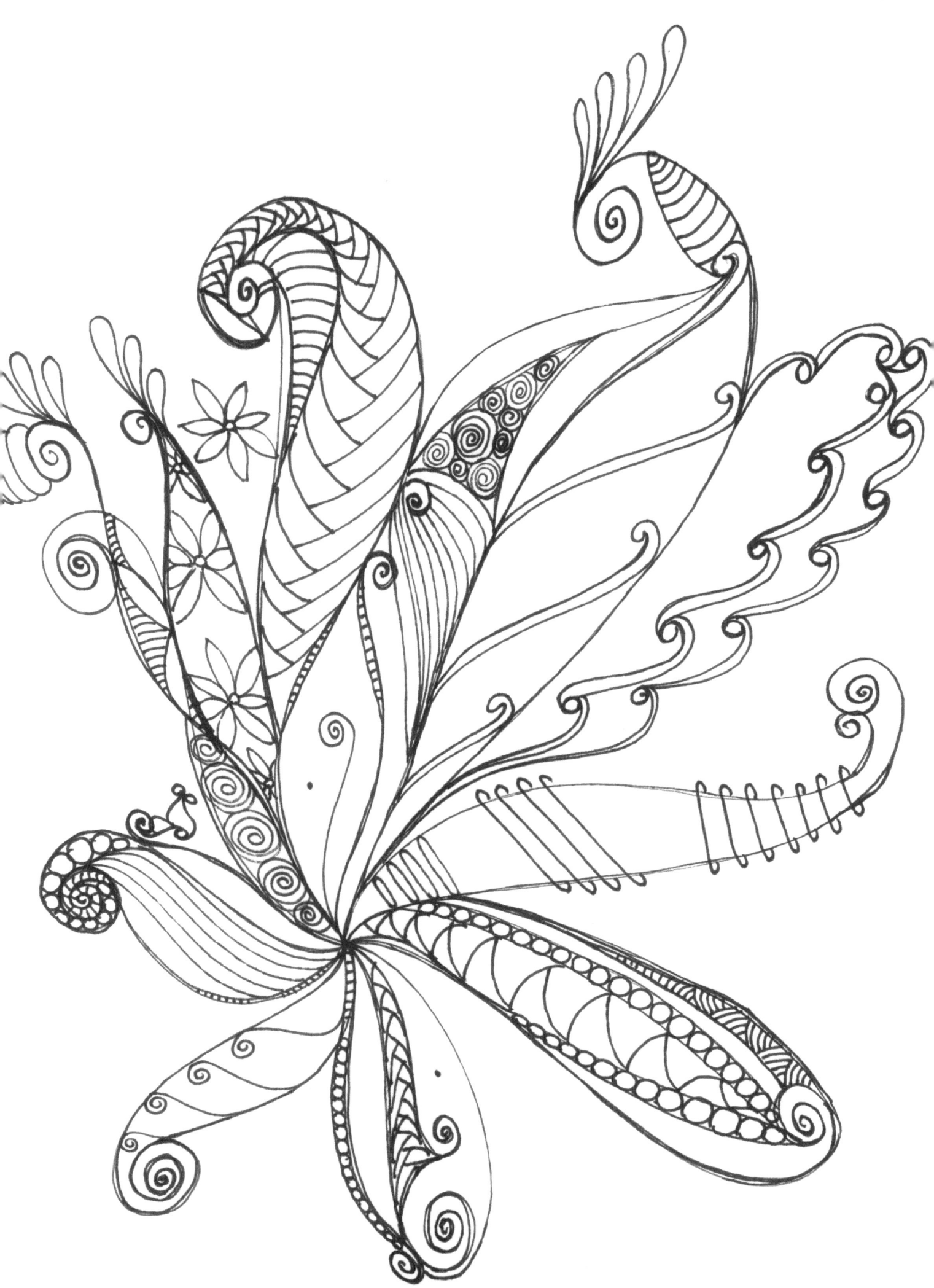

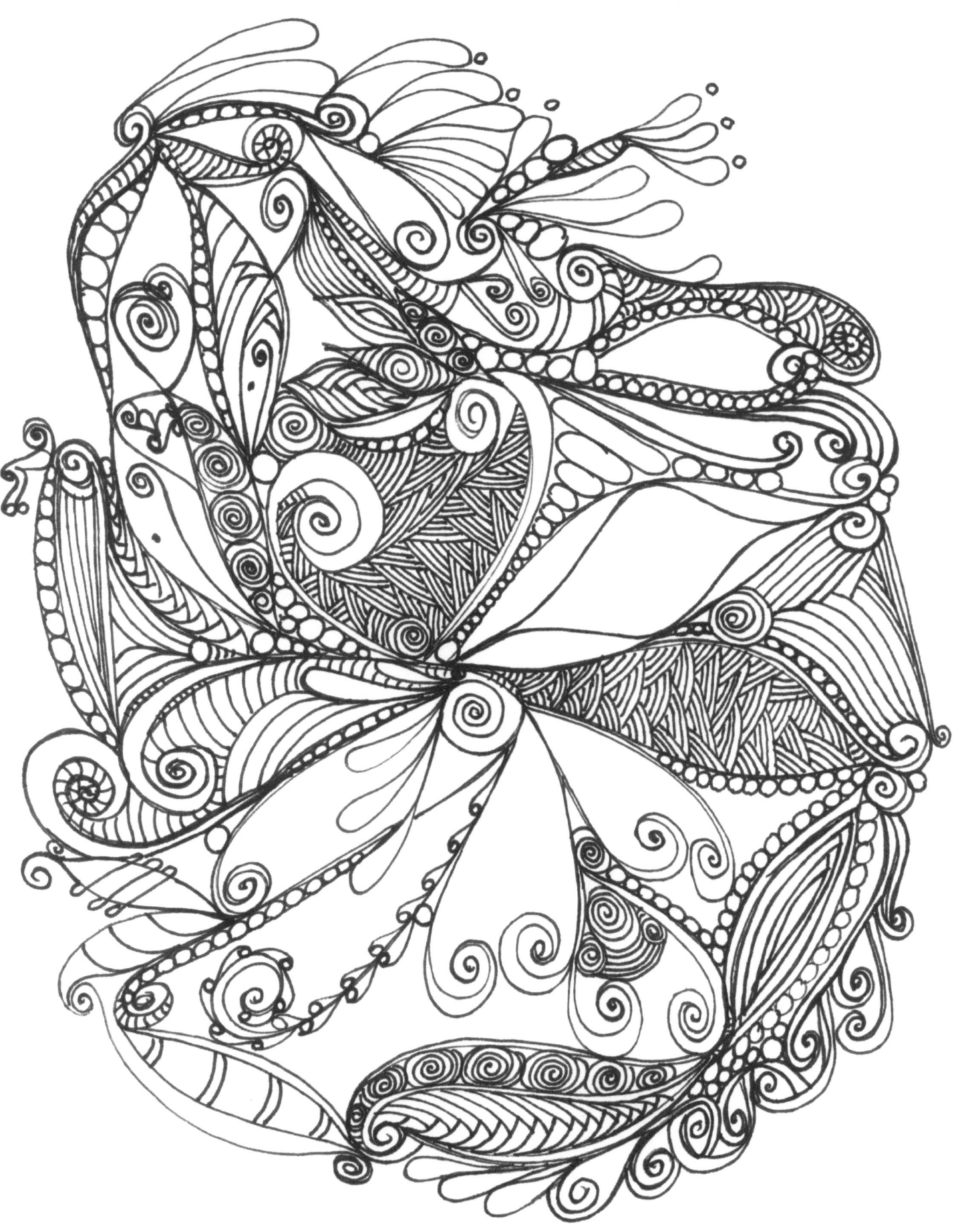

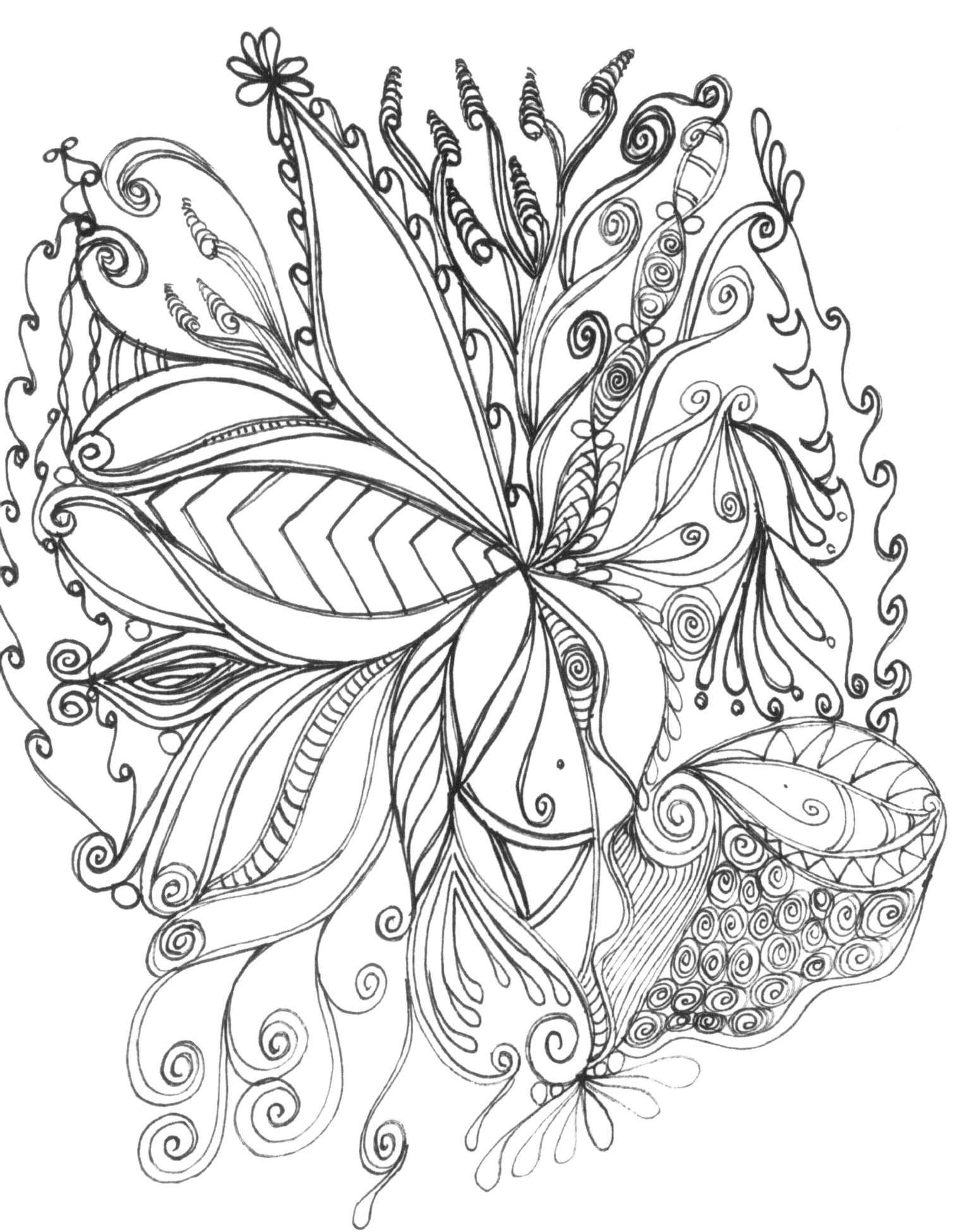

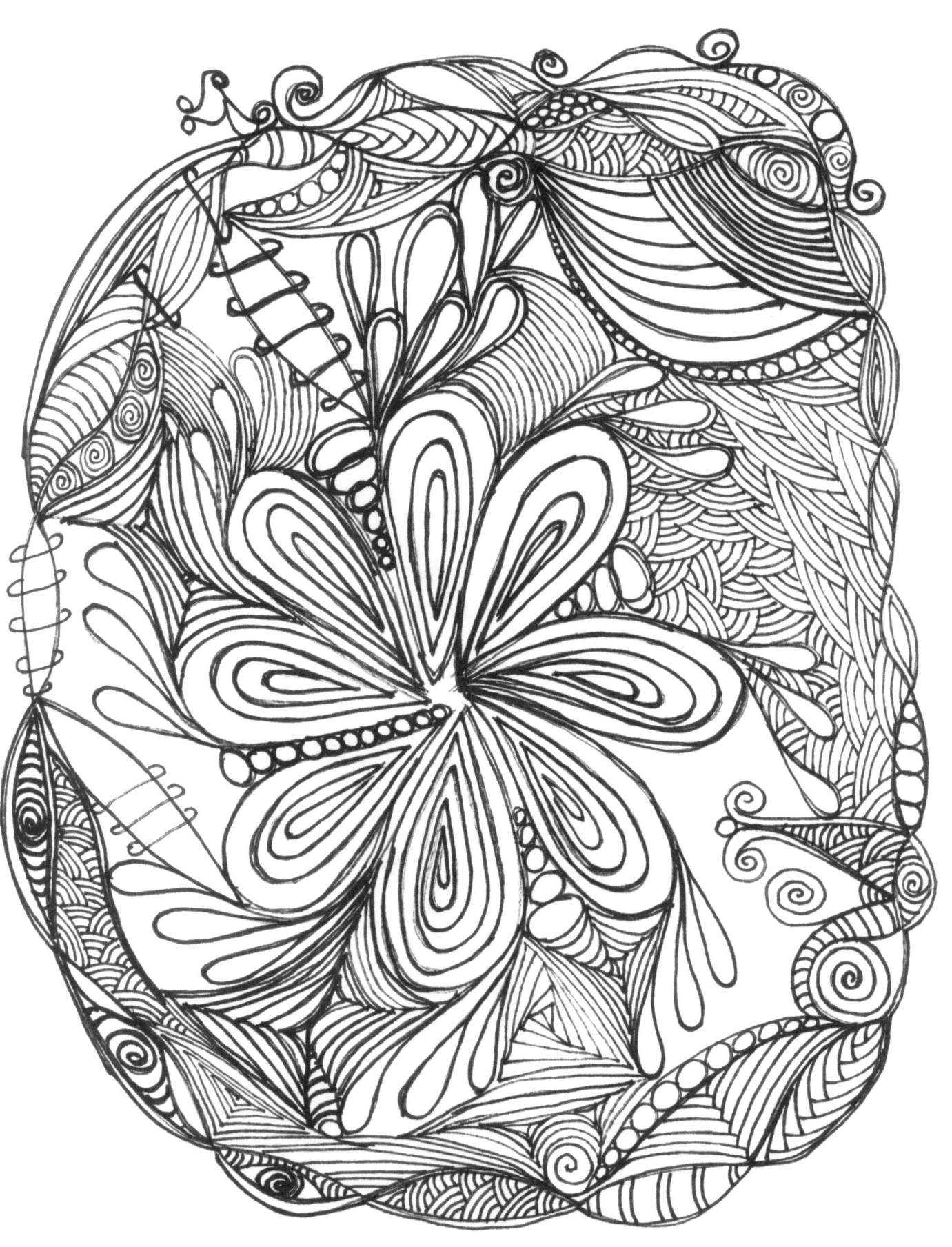

www.ingramcontent.com/pod-product-compliance
Lightning Source LLC
Chambersburg PA
CBHW050738180526
45159CB00003B/1270